UNDERSTANDING
FLASH PHOTOGRAPHY

UNDERSTANDING
FLASH PHOTOGRAPHY

How to Shoot Great Photographs Using Electronic Flash

BRYAN PETERSON

AMPHOTO BOOKS

AN IMPRINT OF THE CROWN PUBLISHING GROUP/NEW YORK

Front cover photograph: Bryan Peterson. Nikon D300, 12–24mm lens at 14mm, ISO 200, f/16 for 30 seconds

Page 1: Nikon D300, 10.5mm lens, ISO 200, f/4 for 1/800 sec., Nikon Speedlight SB-900

Pages 2–3: Nikon D300, 28–70mm lens at 28mm, ISO 200, f/22 for 10 seconds

Page 5: Leica D-Lux 4, ISO 80, f/3.2 for 1/1600 sec.

Pages 6–7: Nikon D300, 12–24mm lens at 13mm, f/22 for 1/250 sec., Nikon Speedlight SB-900

Page 9: Nikon D300S, 105mm lens, ISO 200, f/32 for 1/40 sec., Nikon Speedlight SB-900

Page 10: Nikon D300S, 12–24mm lens at 22mm, ISO 200, f/22 for 1/160 sec., Nikon Speedlight SB-900

Pages 12–13: Nikon D300, 28–70mm lens at 28mm, ISO 200, f/5.6 for 1/8 sec., Nikon Speedlight SB-900

Pages 32–33: Nikon D1X, f/4.5 for 10/16 sec.

Pages 56–57: Nikon D300S, 16–35mm lens at 16mm, ISO 200, f/16 for 1/250 sec., Nikon Speedlight SB-900

Pages 110–111: Nikon D300, 12–24mm lens at 14mm, ISO 200, f/13 for 1/8 sec., Nikon Speedlight SB-900

Copyright © 2011 Bryan F. Peterson

First published in 2011 by Amphoto Books,
an imprint of the Crown Publishing Group,
a division of Random House, Inc., New York.
www.crownpublishing.com
www.amphotobooks.com

AMPHOTO BOOKS and the Amphoto Books logo
are registered trademarks of Random House, Inc.

Library of Congress Cataloging-in-Publication Data
Peterson, Bryan, 1952-
 Understanding flash photography : how to shoot great photographs
using electronic flash / Bryan Peterson.
 p. cm
Includes index.
ISBN 978-0-8174-3956-9 (pbk.)
1. Electronic flash photography. 2. Photography—Artificial light. I. Title.
TR606.P48 2011
778.7'2--dc22

 2010050689

Printed in China

Design by Bob Fillie

10 9 8 7 6 5 4 3 2 1

To my mom and dad:
Thank you for
Giving me life!

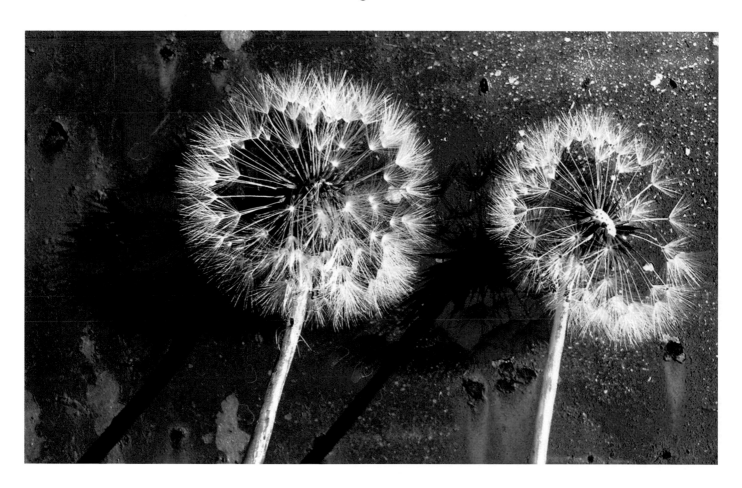

Contents

INTRODUCTION

Dissuaded, discouraged, frustrated, deterred, put off—these are but a few of the G-rated words used to describe many photographers' experiences with electronic flash. Failure with flash—at least in the beginning—is the norm rather than the exception. Ask anyone who has used flash long enough about their early experiences, and they'll be no different than those you're having today. There have been numerous photographers who "get it" when taking pictures in available light as soon as the camera comes out of the box. Unfortunately, I know of no photographers who "get it" when using electronic flash for the first time—or second or third or fourth. Flash can be frustrating, for certain, and your patience will be tested, especially in the early stages.

Most of us instinctively pop up the flash on our camera or mount our portable electronic flash when we find ourselves shooting indoors. Not surprisingly, we expect that flash to simply fill the area we're shooting with perfect light, and we're frustrated when that doesn't always happen. Why do most flash pictures taken at birthday parties and holiday gatherings tend to look so darn harsh? Why do most of our flash pictures look overexposed, underexposed—even scary—with colors never seen when taking pictures outdoors?

And you know what? I'm not exempt from the frustrations of flash photography. As readers of my other books know, I was an antiflash fanatic for more than thirty years. This isn't to say that I've never used flash, because I have, in fact, lit up many a factory during commercial photo shoots in my time. However, that was all done with very powerful studio strobes, sometimes lots of them. I was confident using those studio lights, but they're a different animal from the average portable electronic flash.

So portable electronic flash remained a challenge. During the first ten years of my photographic career, I had seen a few really wonderful images by other photographers who were obviously very comfortable using portable flash. And I'd be lying if I said I never felt envious of these talented shooters. My envy got so bad that back in 1978 I broke down and bought a Vivitar 283 electronic flash. At the time, the Vivitar 283 was the king of kings in the portable strobe market. Truth be told, I used it one time! The stark and unflattering light was, to put it simply, a turnoff for me, and that one time served a single purpose: It strengthened even further my feelings of inferiority when it came to flash. That tiny, portable flash that had brought smiles to so many other shooters absolutely terrified me! There, I said it. Yes, I was terrified of the small, portable strobe.

Terrified of what? you might ask. A number of things, but for starters, I was terrified by its shape. The rectangular shape of these electronic strobes is contrary to the familiar, round shape of the electronic flash tube that's common in most studio strobes. *Round* means even light distribution, just like the sun. *Round* means friendly. *Round* means versatile, as in "well-rounded," which makes me feel comfortable. As one who spent far more time outdoors working with the actual sun and understanding a great deal about light and its direction, I had an easy transition to studio strobes, since they were nothing more than "miniature suns." A rectangular electronic flash, on the other hand, was a foreign tool.

Speaking of the sun and its ever-constant stream of light—light that I could *always* see—another problem with portable flash was that I could never see a constant stream of light coming out of the strobe. When you fire a portable flash, the duration of that flash is so darn quick that you never get the chance to actually see it light the subject, which means you're always in a state of high anxiety until you see how your image turned out.

Most electronic flashes now come equipped with a great deal of sophistication—sophistication that is intended to make our lives easier. Ha! If you know me, I hold the same disregard for flash automation as I do for the sophisticated automation offered by just about every DSLR on the market. The only thing all of this flash automation has done is increase most people's anxiety. The manual that comes with most electronic flashes is upward of ninety pages! Yet, there are usually just three pages written about using your flash in manual exposure mode, and these three pages may be the most useful in the entire manual! Sure, you want to learn how to tilt and rotate the flash head, put on colored gels, and attach a diffuser, but at the end of the day, the *most important* thing you want to learn is how to use your flash in manual exposure mode.

If you've read my book *Understanding Exposure*, which deals almost exclusively with available light, you know the emphasis I place on what I call the *photographic triangle*: ISO, aperture, and shutter speed—with a further emphasis on the heart of the photographic triangle, light. In this book, you will discover that the photographic triangle is still alive and well when using flash. At the heart of the triangle you'll still find light, but with the addition of a portable, incredibly powerful "miniature sun": the electronic flash. This book builds on the manual exposure foundation that I detail in *Understanding Exposure*. Electronic flash does not require a new way of shooting. It does not require a new photographic mind-set. Flash is simply a supplementary tool that we add to our other fundamentals to augment the light in certain situations. When you operate with that understanding, and once you've mastered the manual exposure operation of your flash, you'll be able to get a perfect flash exposure every time.

I maintained a fear of flash for nearly three decades, but obviously the walls of resistance eventually tumbled down, since you hold in your hands a book about flash photography. This onetime nonbeliever is now perhaps one of the biggest converts out there. By applying the principles of the photographic triangle and the techniques of manual exposure, I discovered that flash is a necessary and immensely creative tool that increases creative opportunities hundredfold. And you will, too. Once you fully understand electronic flash and how it works, your eyes will be opened to a new level of photographic versatility. No more tossing images in which the light was too contrasty, too dark, or too weak and flat. Rather, you'll discover how flash can be used to reduce high-contrast sunlight or even *simulate* sunlight when the sun isn't out. You'll understand how to use that teeny-weeny, built-in flash for better photographs while also learning its limitations as compared to a larger, external flash. You'll also find out how to freeze a moving subject with flash and prevent blurring, how to photograph a traditional studio portrait, and how to create light in ways you could only imagine previously. And when you make it a point to combine what you know about available light with what you are about to learn about artificial light, you, too, will be unstoppable!

Finally, in the tradition of saving the best for last, the use of electronic flash with the instant-feedback monitor on the back of your DSLR will guarantee flash success as long as you resign yourself to becoming a "chimping" addict (chimping is the reviewing and then trashing of unsuccessful images in camera using the LCD screen). I chimp with zeal and, when necessary, adjust my flash exposure accordingly. It's one addiction I will not be giving up anytime soon, and you shouldn't either. It's a technology available to us all, so why not use it?

If you stick with flash, your patience will be amply rewarded. When you do "get it"—and you will—the journey ahead is filled with unlimited discoveries! You will reach that level of enthusiasm where you feel your capabilities with your flash, your miniature sun, are boundless. Flash photography can add light to what you want, when you want and where you want it. Considering the size of our planet, that provides a lot of opportunities, and your flash journey will, indeed, be long and exciting.

POP-UP VS. PORTABLE ELECTRONIC FLASH

Almost all of today's DSLRs come with a pop-up flash that you can set to engage automatically when the camera's light meter dictates or can fire manually. These can be useful in a pinch, but this book deals primarily with external flash units—i.e., portable electronic flash that can be mounted on the camera's hot shoe or used off camera with a remote trigger. These flash units, which include the Nikon Speedlights and Canon Speedlites, have a range of metering and automation features that I'll discuss later. Unless otherwise noted, when I speak of flash, I'm speaking of these portable electronic flash units.

LIGHT, THE PHOTOGRAPHIC TRIANGLE & FLASH

Light and How the Camera Sees It

Understanding light should be at the top of your photographic-priorities list. Light *is* photography. Without it we are doomed. Good photographic light isn't limited to the sun, yet I, like so many other shooters, held on to that belief for years. Only recently did I begin to embrace another light source, a light source I affectionately call my "miniature sun": electronic flash. No matter what Mother Nature may have in store, I can still head out the door, confident that I carry with me "a little ray of sunshine." Sometimes, that little ray has made all the difference.

Light is all around us and comes from many sources, visually sculpting our world by creating highlight, shadow, and shape. Some light we can control, and some we can't. For example, if light is too bright, too harsh, too dark, or too soft, we may be able to simply turn a lamp off or on. In other cases, we have no control. Existing light sources, whether artificial or natural, are called *available light* or, more commonly, *ambient light*. These are, unlike flash, constant light sources and are usually always on. The sun is ambient light and is "always on" during daylight hours. A streetlight is ambient light and is always on during evening hours. Lights in a grocery store or office are ambient light and are almost always on.

Light from an electronic flash, on the other hand, is *supplementary light*. Unlike most ambient light sources, electronic-flash light is 100 percent under your control. You have the choice of illuminating a large area or a small one—and from just about any angle you can imagine. What's truly exciting about using flash is that you get to control its contrast, brightness, and volume—all while maintaining complete control over the ambient light and its resulting exposure. With one or more electronic flashes in your camera bag, you'll begin to feel that you've discovered your own planet where numerous suns are rising and setting at the same time, under your command, casting light in places of your choosing!

But before you can master flash, you have to understand how the camera "sees" light. Perhaps you're familiar with seascapes by painters who capture a very bright, colorful sun setting in the background while maintaining vivid and bright details of the sand, surf, and nearby rocks in the extreme foreground. Ever try to take a photograph of an ocean scene like that? If so, you were probably disappointed. The human eye is an amazing machine that can see a broad range of light and dark simultaneously. Compared to what your digital sensor (or film) can actually see and record, our eyes can see much, much more. A typical digital sensor records an estimated 7-stop range of light and dark. Our eyes see an estimated 16-stop range. A painter who sees a seaside scene in the entire 16-stop range paints a landscape in which all 16 stops are represented, from light to dark. Your camera only records a fraction of that.

The solution? Your portable miniature sun. By adding supplemental light in the right parts of the foreground, your camera's sensor can "see" those portions of the scene that were previously too dark. With your electronic flash, you, too, can achieve an image on par with a fine painting.

Photographers and painters have been manipulating light for centuries, and when used well, a flash can be perhaps the best manipulator of all. Depending on how you shape it or color it, flash can add drama, mystery, and surprise to an otherwise mundane scene, even turning day into night or night into day.

POSING IN FRONT OF THE CHICAGO LANDMARK WOLFY'S *on Peterson Avenue, my friend Jon Demopolous helped me demonstrate how to combine electronic flash with a storytelling aperture (one that renders great depth of field from front to back and contains distinct foreground, middle-ground, and background elements as different parts of the story).*

Similar to a sunset seascape, the range of light in this scene was greater than what the camera was able to capture. If I exposed for the sign and sky, Jon would be underexposed and show no detail; if I exposed for Jon, the background and that great sign would record way overexposed. That's where flash comes in.

With my camera and lens mounted on tripod, I set an aperture of f/22, because I wanted maximum depth of field. I then adjusted my shutter speed until my camera's light meter indicated that 1/4 sec. was the correct exposure for the sky and neon sign (with ISO 200). The resulting available-light exposure above is spot-on for that area. Jon, on the other hand, is much too dark. So I dialed in f/22 on the back of my flash, and the flash distance scale (see page 34) indicated a flash-to-subject distance of 4.4 feet for a correct flash exposure.

With my flash tethered to a remote flash trigger (see page 122) so that it was ready to fire remotely, I held the flash up high with my left hand, just to the left of Jon, and pointed down at about a 30-degree angle. I then tripped the camera's shutter release with my right hand while Jon began to bite down on his hotdog. Voilà! The background is properly exposed, while the foreground is also illuminated. The satisfaction of eating a Wolfy's Dog has been recorded.

Both photos: 12–24mm lens, f/22 for 1/4 sec. Bottom: with Speedlight SB-900

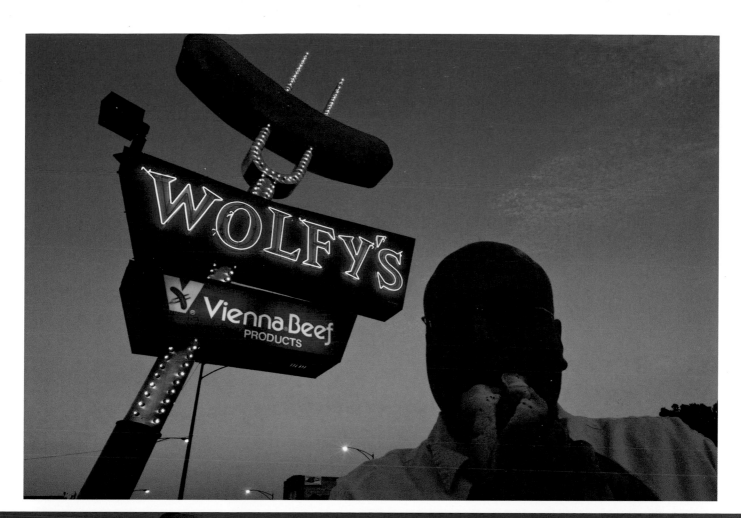
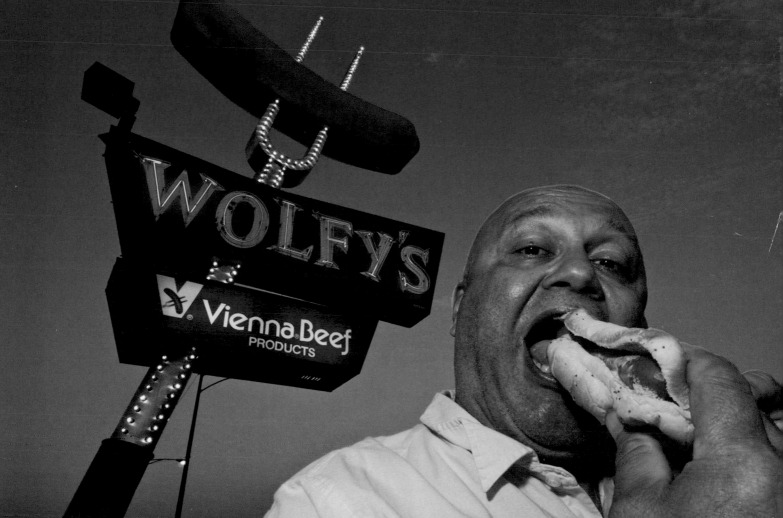

The Inverse Square Law and Light Falloff

All light is mysterious, but flash is especially mysterious, and I'm convinced it's partly because the flash burst is so fast that if you so much as blink, you can't say for sure that the flash even fired. Even if you did see it fire, you can't say where the light went or how far it traveled.

If you've tried to understand how your flash works at all, you have perhaps come across a number of articles both in books and on the Web that talk about the Inverse Square Law. What is this law? Well, the light output from your flash is a physical quantity, and the Inverse Square Law deals with the falloff of light in relation to the distance from flash to subject. And it's a good concept to get a handle on before we move on to the specifics of making flash exposures.

Think about it this way: You're at an indoor concert, and you hold your camera up to photograph the musicians onstage. When you check the shot, you see that the people 3 feet in front of you have "skin burn" from the flash because they were too close to it. The people ten rows ahead are perfectly illuminated, and the musicians onstage are dark because the flash never reached them. Despite the flash's best attempt to illuminate the subject (in this case, the musicians), the light *fell off* dramatically before reaching it.

Simply put, the Inverse Square Law states that as the flash-to-subject distance doubles, the light reaching the subject is only 25 percent of the original light that left the flash. So, for example, what this means for photographers is that if you move your subject from 5 feet to 10 feet away from the light source, you'll need four times the amount of light to get the same exposure at 10 feet that you got at 5. It's also good to be aware that the closer something is to the light source, the faster the light falls off; the farther it is from the light source, the slower the light falls off. So falloff will be more pronounced up close.

The falloff explained by the Inverse Square Law accounts for much of the disappointment many of us have felt when shooting flash exposures. But this fundamental principle is logical when you think about it. When you're out in your front yard setting off firecrackers, you don't expect everyone within six blocks to hear the same exact loud bang, do you? Of course not, because you know all sounds eventually fade to silence. The light output of your flash works the same way. Just like the bang of a firecracker, it falls off quickly.

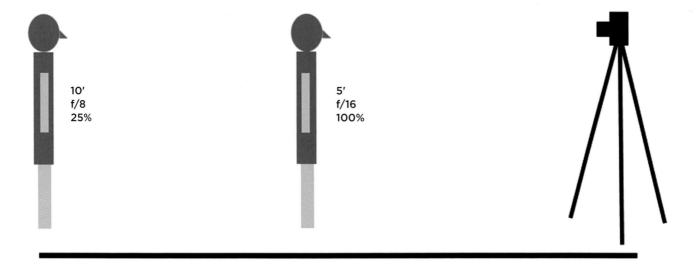

10'
f/8
25%

5'
f/16
100%

THIS DIAGRAM ILLUSTRATES *the Inverse Square Law. Let's say your subject is 5 feet from the camera and your perfect exposure is f/16. When the subject is moved to 10 feet away, or double the distance from the flash, only 25 percent of the light from your flash will still reach the subject. Because of this, the new f/stop would be f/8, or 2 stops more than at 5 feet, to let in more light.*

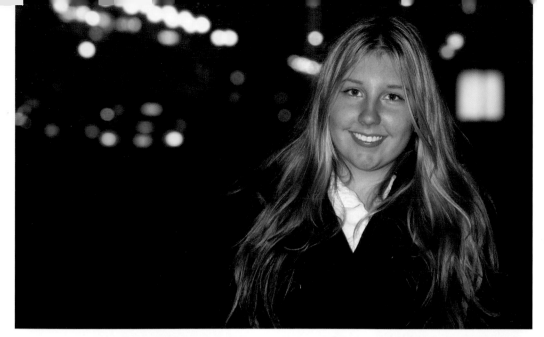

CHLOË AND I HEADED OUT
the door for some "festive city" photos, and as these shots clearly show, there's a definite difference in each of the flash exposures—and that's courtesy of the Inverse Square Law. The first example (top) combines a perfect flash exposure with a perfect ambient-light exposure. The ambient-light exposure was f/8 for 1/15 sec., and based on f/8, the correct flash-to-subject distance was 15 feet, which was where Chloë stood (15 feet from me).

But note how she becomes progressively darker (center and bottom). This happens for one reason and one reason only: The distance between the flash and Chloë has increased. Center, the flash distance between Chloë and the flash was 21 feet; and bottom, the flash was at 26 feet. The exposure used was the same in all three shots, but the flash-to-subject distance increased, and therefore light falloff accounts for Chloë being too dark.

All photos: f/8 for 1/15 sec., Speedlight SB-900. Top: subject at 15 feet. Center: subject at 21 feet. Bottom: subject at 26 feet

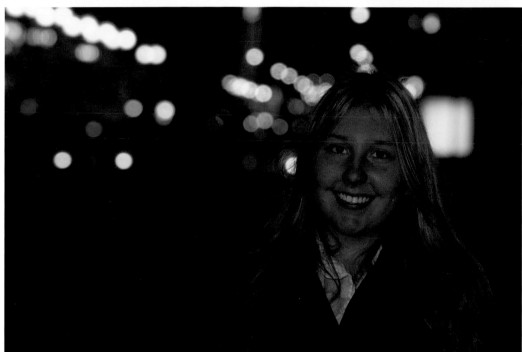

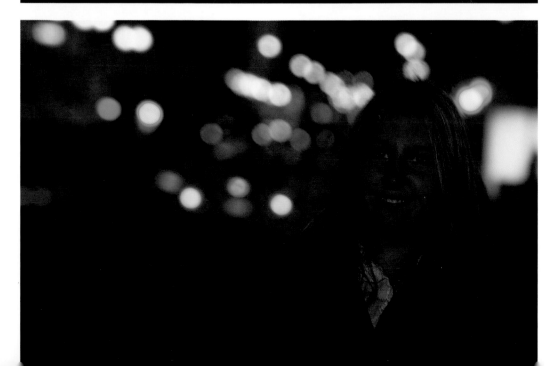

The Photographic Triangle

I f there's one area in photography that seems to have created its own set of rules, it is the use of electronic flash. For many photographers, the rules suggest that electronic flash requires a completely different approach to image-making. Nothing could be further from the truth, and I'm here to say that over the course of these pages the mystery of electronic flash will be exposed!

If you're familiar with my book *Understanding Exposure*, then you will fully appreciate this one simple fact: Everything you learned in that book about what I call the *photographic triangle* still applies when using electronic flash. If you have any interest in fully exploring and exploiting the sheer joy of this tool, then it's absolutely vital that you keep the photographic triangle in the forefront of your mind when you pull out your flash.

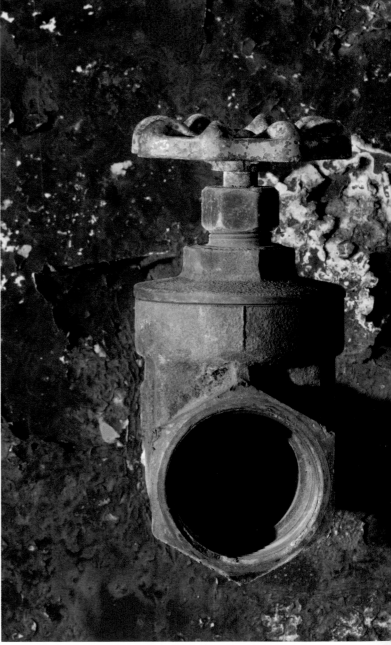

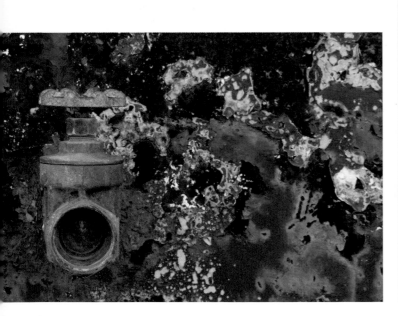

THIS WAS AN EASY EXPOSURE in the overcast light. As I've done for years now, I simply asked myself if there were any depth of field concerns in this scene, and the answer was no, since everything is basically at the same focused distance. So I chose the critical aperture of f/11 for maximum sharpness and simply adjusted my shutter speed until the camera's light meter indicated 1/15 sec. would get a correct exposure.

But I also wanted to emphasize the texture and form in the scene, so I called on my Nikon Speedlight SB-900 portable flash. Keep in mind that my choice of which aperture to use for a correct exposure—even when using my flash—is still based on what concerns if any I might have regarding the depth of field. And again, with or without flash, this scene and it's focal distance is not going to change one iota, so it was easy to decide to keep that aperture of f/11.

So with the aperture still at f/11, the distance scale on my flash told me that I could use a flash-to-subject distance of 3 feet at 1/8 power (see page 40 for more on this). Since I didn't want the ambient light to affect the exposure, I further adjusted my shutter speed from the normally correct ambient exposure of 1/15 sec. to a much faster speed of 1/125. This 3-stop increase (from 1/15 sec. to 1/125 sec.) assured me that the ambient light would record as a 3-stop underexposure. A 3-stop underexposure will often result in the "killing" of the ambient light, and at least in this case, killing the ambient light was critical so that I could allow only the "sunlight" from my strobe to function as the light source. (Note: You won't always want to kill the ambient light, as you'll see later on.) So, with my flash held off to the left at a distance of about 3 feet from the faucet and textured surface, I fired away. Voilà! That little ray of sunshine— and the resulting shadows— emphasized all the texture in the subject.

Both photos: 105mm lens, ISO 200. Opposite: f/11 for 1/15 sec. Left: f/11 for 1/125 sec., Speedlight SB-900

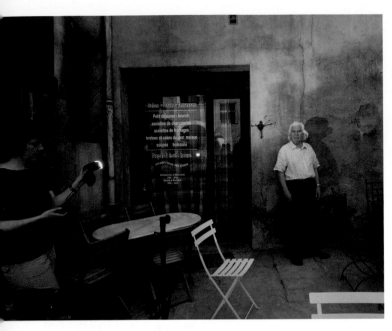

WHILE CONDUCTING A WORKSHOP in Lyon, France, I asked one of my students, Dennis, if he would pose for a simple portrait. Because there were no depth-of-field concerns, I was able to use the critical aperture of f/8. (Critical apertures—f/8, f/9, f/10, and f/11—render the greatest sharpness.) So, with the aperture set to f/8 on my lens and dialed in on the back of the flash, I directed another student to hold the flash and stand at the correct flash-to-subject distance, which was 11 feet according to the scale on the back of the flash. Before firing the flash, I used my camera's light meter to determine that the available-light exposure for this scene in open shade was f/8 at 1/30 sec.

My goal was a warm, "sunlit" portrait, so I first had to figure out how to overcome the available light. With an ambient exposure of 1/30 sec. at f/8, I simply sped up the shutter speed to 1/250 sec., a 3-stop underexposure that effectively negated the ambient light. Without this faster shutter speed, I would have gotten an unwanted mix of overcast light and flash, resulting in a washed-out portrait. An amber gel added to the front of the flash completed the effect, making the light of one small flash look like the light of the setting sun.

Nikon D300S, 105mm lens, f/8 for 1/250 sec., Speedlight SB-900

Let's review this idea briefly. Every single available light exposure is a combination of three factors: aperture (f-stop), shutter speed, and ISO, which make up the photographic triangle. How do these three elements work together to create an exposure? If I'm photographing on a sunny day with ISO 200, I can generate a correct exposure with an aperture of f/16 and a shutter speed of 1/200 sec. If I change my ISO to 800, that same exposure at f/16 now requires 1/800 sec. to be correct. The higher ISO makes the camera's digital sensor more sensitive to light, and since a shorter shutter speed lets in less light, 1/800 sec. compensates for the increased light sensitivity. When you think of ISO numbers as light-gathering receptors, it becomes clear that the more light-gathering receptors you have (i.e., the higher the ISO number), the quicker you can record an exposure: f/16 for 1/800 sec. is a faster exposure than f/16 for 1/200 sec.

In my own work, I spend 98 percent of my time with the ISO set at 200, whether I'm using flash or available light. In combination with light, it is the constant ISO 200 that dictates which combinations of aperture and shutter speeds I can use for a given shot. Suffice it to say, of the three factors that make up the photographic triangle, ISO is the one element I'm quick to set (to 200) and then forget about!

On the other hand, you'll always want to be on the lookout for opportunities to use various apertures and/or shutter speeds, since one or the other or both will render the most creative exposures. In fact, every picture-taking opportunity presents six possible combinations of aperture and shutter speed that will all render a correct exposure for a given scene. For example, if a scene can be exposed at f/4 for 1/2000 sec., then that same scene can also be correctly exposed at f/5.6 for 1/1000 sec., f/8 for 1/500 sec., f/11 for 1/250 sec., f/16 for 1/125 sec., and f/22 for 1/60 sec. With each increase in f-stop (i.e., each decrease in aperture opening size), the amount of light on the camera's sensor is reduced. You are compensating for this reduced light by lengthening your exposure; the longer (or slower) the shutter speed, the more light you're letting hit your camera's sensor. In terms of quantitative value, each of these six exposures is correct. However, a full understanding of exposure also means that we want not only a correct exposure but the most *creatively correct exposure*. So which one of these six exposures is the most creative exposure? That depends on what you want to convey with your imagery.

As I discuss in *Understanding Exposure*, the apertures of f/16 and f/22 create what I call storytelling images,

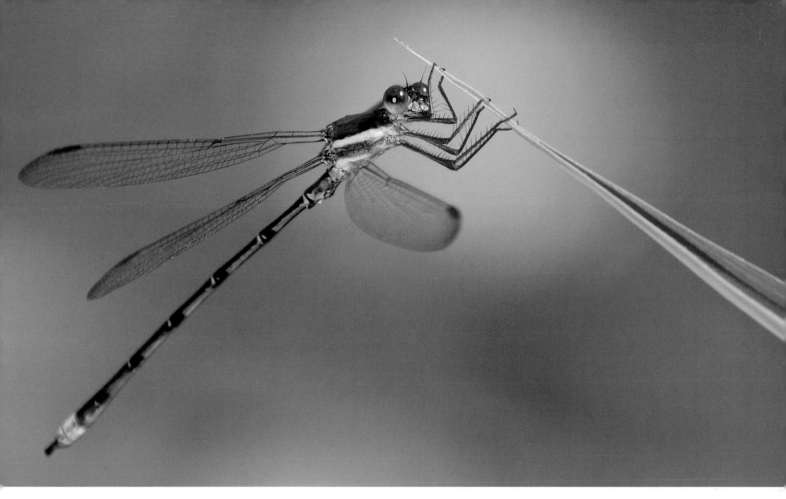

because the great depth of field they capture from front to back in a scene enables to the photographer to tell an entire story. Apertures of *f/2.8*, *f/4*, and *f/5.6* create what I call singular-theme or isolation images, because the shallow depths of field they render isolate subjects against softly focused surroundings. And finally, apertures of *f/8* and *f/11* are ideal for what I call "Who cares?" compositions, meaning depth of field is not a major concern, so "Who cares about depth of field?"

Similarly, different shutter speeds also yield different effects. Fast shutter speeds (such as 1/1000 sec., 1/500 sec., and 1/250 sec.) freeze action, and slow shutter speeds (1/4 sec., 1/2 sec., 1 second, and slower) imply motion by allowing panning or simply by blurring the action. When you're about to make an exposure, you should ask yourself, Is the scene before me more about creative use of aperture or shutter speed? Once you decide, you then control the creative exposure by first selecting either the right aperture for the depth of field you wish to record or the right shutter speed for the motion effect you wish to capture (and then next selecting the remaining leg of the triangle, whether it be shutter speed if you've first selected the aperture or aperture if you've first selected the shutter speed).

There really is an unlimited world of creative exposure opportunities. And now for even more good news: The choice to tell a story or isolate, to freeze action or imply motion, is still yours—even, as you'll soon see, when using your flash!

THE SWEAT WAS POURING OUT OF ME *as I pursued the many dragonflies at the Zilker Botanical Garden on a hot August morning in Austin, Texas. The object of my desire was a small damselfly that had taken refuge on a blade of grass in open shade, yet my point of view was such that the background was in full sun. No doubt about it, this shot would require a large lens opening so that I could isolate that lone damselfly from an otherwise busy background. Plus, I needed flash. Lighting up the bug with flash would avoid producing a dark, silhouetted shape and would show the damselfly's colors.*

With my camera mounted on tripod, I set the aperture to f/5.6 to get the very shallow depth of field that would render the background as out-of-focus tones. The addition of a small extension tube also allowed me to focus much closer, and when combined with the focal length choice of 300mm, that little damselfly filled up my frame nicely. But as you can see opposite, a simple ambient-light exposure silhouetted the subject.

Calling on my portable electronic flash, I quickly set my aperture to f/5.6. The distance scale on the back of my flash told me that if used at full power the flash needed to be 27 feet from the subject. Yikes! I couldn't have placed that flash 27 feet away from the damselfly if I wanted to; about 4 feet behind me was nothing but a jungle. No problem. I just powered down the flash. As I did this, the flash indicated that at 1/16 power I could shoot at f/5.6 at 4 feet from the damselfly.

I get into powering down the flash in more detail on page 40. For now, just know that you have the very useful option of reducing your flash power when you can't change your flash-to-subject distance—so that you don't overpower your subject with a superbright flash. Once I'd made the adjustment, I pressed the shutter release and bingo, bango, bongo! The little damselfly lit up like a neon sign, and I maintained a correct exposure of the brighter ambient background.

Both photos: Nikon D300S, Nikkor tele-zoom lens at 300mm, extension tube, f/5.6 for 1/250 sec. Above: with Speedlight SB-900

Aperture: The Key to Correct Flash Exposures

Before we solidify exactly where electronic flash fits into the photographic triangle, it's important that you, too, think of your flash as the "miniature sun" I've been referring to. The sole purpose of your miniature sun is to add light to those areas of your composition where the light (or lack thereof) doesn't meet your preference.

Assume for a moment that you're a magician. You wave your magic wand over a scene, and after a few abracadabras, sunlight appears in areas that were once in open shade. Or light (whether outdoors or indoors) begins to illuminate the front of a backlit subject. Or you create low-angled sunlight, like the glow from early morning sunlight, to create frontlight, even though it's an overcast day. To perform these tricks, you must first understand the workings of your magic wand—i.e., your electronic flash. If your flash is going to work its magic time and time again, it can only do so if the following two conditions are met: (1) the right aperture is set on your camera, and (2) this correct aperture is determined by the distance between your subject and the flash.

Your portable electronic flash should have a distance scale on the back that allows you to determine the correct aperture for your exposure based on the distance between the flash and the subject and on whether you're using the flash at full power or are powering it down to a fraction of its full strength. I'll cover the distance scale in more detail on page 34, but this is the tool that will tell you the correct aperture for a manual flash exposure based on your distance to the subject.

I can't stress enough that a correct flash exposure is 100 percent determined by the aperture. Your flash doesn't care what shutter speed you use. This news may come as a surprise. Many of you have been led to believe that a correct shutter speed, the *sync speed*, is vitally important when using flash, but that's a myth, as we'll see as we progress. The sync speed is simply the fastest shutter speed you can use with your flash. Lowering the shutter speed allows you to manipulate the ambient light in your overall composition, and manipulating this ambient light is what often creates much of the drama in exposures that include both flash and natural light.

As the principles of the photographic triangle tell us, both aperture and shutter speed work in combination to create a perfect exposure when shooting in natural light. Hopefully, you're now in the habit of asking yourself what kind of picture you wish to take (storytelling, isolation, or "Who cares?"). Your answer to that question will determine which aperture to use. Now, this may come as a surprise, but when you add flash, I do *not* want you to change a thing in your approach to image-making. Why? Because it's the flash-to-subject distance that determines which aperture you can use. And you can always move your portable electronic flash closer or farther away (or you can power it down). And because your flash is, indeed, portable, you can almost always move it to the distance required by a particular aperture, so you can still use storytelling, isolation, or "Who cares?" apertures to make your ideal composition.

LET THERE BE LIGHT! *The amount of the light output from your flash that reaches your digital sensor is 100 percent dependent on combining the right aperture with the right flash-to-subject distance. A bit of grass against a rusty 55-gallon drum illustrates the importance of this simple fact. As you can see top left, there was no sunlight. I captured the rusty barrel and tall grass on this overcast day with f/11 for 1/30 sec. and only ambient light.*

The image at top right shows the addition of some "sunlight" with flash. As you just read a moment ago, when you want to kill the ambient light, you should strive for no less than a 3-stop underexposure of the ambient light, so with my aperture still set to f/11 but my shutter speed now set to 1/250 sec., all that remained was to fire up the flash and dial in the aperture on the flash unit to f/11. When I did this, the flash distance scale (see page 34) stated that the flash-to-subject distance must be 9 feet to record a correct flash exposure. Turned out I was about 9 feet away from the subject, so I fired off the shot in what now looked like low-angled, natural sidelight, complete with the telltale signs of sun and shadow. I held the flash in my hand, off to the left a bit, and fired it wirelessly with Nikon's Commander mode feature. (Canon also has a similar feature on some cameras.)

And just to prove how integral the proper aperture is with flash, note how much darker the exposures became (bottom, left) as a result of my changing the aperture from f/11 to f/16 and (bottom, right) as a result of going from f/16 to f/22. The smaller apertures greatly reduce the amount of flash light that hits the camera sensor. A great example of how aperture and flash-to-subject distance control the flash exposure—always!

All photos: 70–300mm lens at 135mm, Speedlight SB-900. Top, left: f/11 for 1/30 sec. Top, right: f/11 for 1/250 sec. Bottom, left: f/16 for 1/250 sec. Bottom, right: f/22 for 1/250 sec.

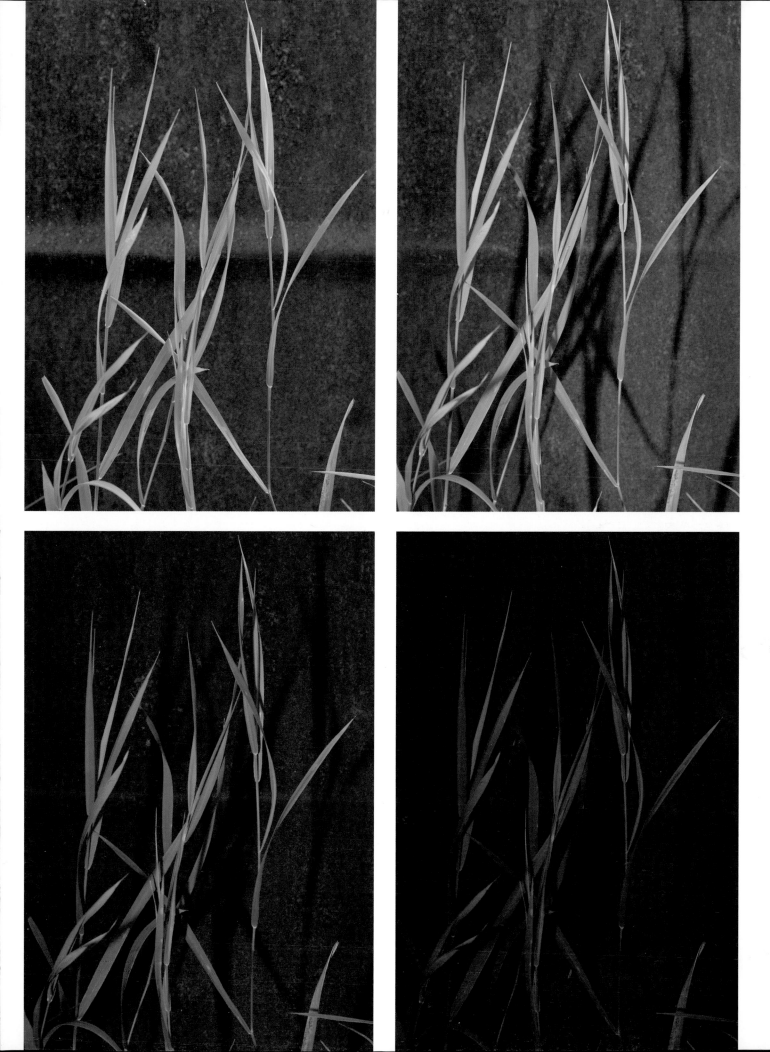

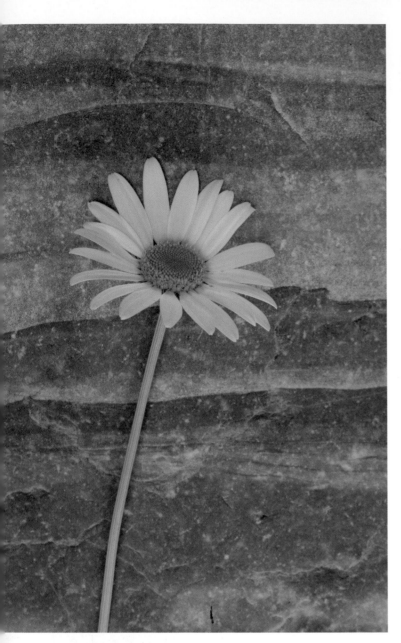

TWO RULES FOR FLASH PHOTOGRAPHY

Flash photography follows the same principles as manual-exposure photography in natural light. The only difference is the addition of supplemental light from a portable "miniature sun." With that in mind, these are the only two rules you need to remember when shooting with electronic flash:

1. The aperture—and *only* the aperture—controls the *amount* of electronic flash light allowed to expose the picture. All flash exposures are 100 percent dependent on the right aperture being selected *and* the right flash-to-subject distance that corresponds to that aperture choice. And with the ability to adjust the power of the flash at any moment (see page 40), your aperture choice is virtually guaranteed no matter how close your flash is to your subject!

2. The shutter speed controls the *amount of time* that any ambient light is allowed to expose that same picture for which you're also using a flash.

Unless you're shooting in a completely darkened room, there's always ambient light present, and it's your creative input that decides how much or how little of this ambient light contributes to the light from electronic flash in your exposure. The reason for this is that the flash fires quickly and then that light source is gone. At that point, the shutter speed is either ending the exposure (if it's fast) or extending the exposure (if it's long) by keeping the shutter open to let ambient light continue to hit the digital sensor. (This is discussed more on page 28.)

I'M OFTEN ASKED, *Does it matter what shutter speed I use, as long as my shutter speed is in sync with my flash? My answer is always the same question: How much of the available light do you wish to record in your overall exposure? While it's aperture that controls the light exposure emitted by the flash, the shutter speed controls the ambient-light exposure in your composition.*

Consider these three examples made on an overcast day in Glacier National Park. With my camera and lens mounted on tripod, I made the first exposure (opposite, left) of f/11 for 1/45 sec. using only ambient light. After setting my flash for an exposure of f/11, I shot again for 1/45 sec. (opposite, right). As you can see, the combination of flash and overcast natural light resulted in an overexposure of both the flower and the rock. Sure, there's a subtle shadow, but it's an overexposed shadow, because the combination of available light and the light output from the flash was too much.

The third time (right), a much more pleasing image resulted when I increased my shutter speed to control the ambient-light exposure. If the correct available-light exposure is f/11 for 1/45 sec., how much of that available light will I see if I set my shutter speed for 1/250 sec.? Again remember, you need as close to a 3-stop reduction as you can get to kill the ambient light. In this case, there's a bit more than a 2 1/2-stop underexposure (1/45 sec. to 1/250 sec.). Since there's a 2 1/2-stop difference between that and the correct available-light exposure (f/11 for 1/45 sec.), all of the illumination will be from the output of the flash. The result is the now-correct exposure in which a shadow is apparent against a perfectly flash-exposed rock. Using Nikon's Commander mode, I held the flash with my left hand above the rock in a twelve o'clock position, which accounts for the shadow seen here in the six o'clock position.

All photos: Micro-Nikkor 105mm lens. Opposite, left: f/11 for 1/45 sec. Opposite, right: f/11 for 1/45 sec., Speedlight SB-900. Right: f/11 for 1/250 sec., Speedlight SB-900

The Role of Shutter Speed in Flash Photography

There is a direct relationship between *f*-stops and correct flash exposure, while your choice in shutter speed is more *indirectly* related to correct flash exposure. That is, since a flash's output duration is instant (milliseconds), the shutter speed doesn't control the exposure of the flash itself but what happens *after* the flash fires. Think about it. If your shutter speed is 1/60 sec. and the flash duration is 1/5000 sec., then the shutter remains open for what comparatively is an eternity after the instant burst of light from the flash. This is where shutter speed has its influence, as the images on page 25 show. This is true whether you're using a shutter speed of 1 second or 1/125 sec. The flash's *output duration* is relatively the same—it's an instant burst of light that occurs quickly *within* the time the shutter is open.

(For you photo scientists out there, you're right: The actual duration of the flash can vary widely. If the flash is at full power, the duration of the flash "spike" might be around 1/1000 sec. Change to 1/4 power, and it will be around 1/2500 sec. And if you go all the way to 1/128 power, the flash spike duration is around 1/40000 sec. Each of these flash duration speeds still fits within the time the shutter is open. Even for superfast shutter speeds like 1/8000 sec., most modern flash units have a high-speed sync mode that keeps the flash spike within the shutter opening time, and there's more on sync speeds on page 62.)

So shutter speed doesn't actually control the flash exposure itself, but it does control the *ambient light*. Putting the use of flash aside for a moment, you know that when shooting in natural light, you adjust your shutter speed and/or aperture to arrive at a correct exposure. And if the exposure for this natural light is wrong, your picture is too light or too dark. Let's say you're shooting some flash pictures outside around dusk. Despite the fact that you're using your flash (which is controlled by aperture), you can still have total control of the natural light. You

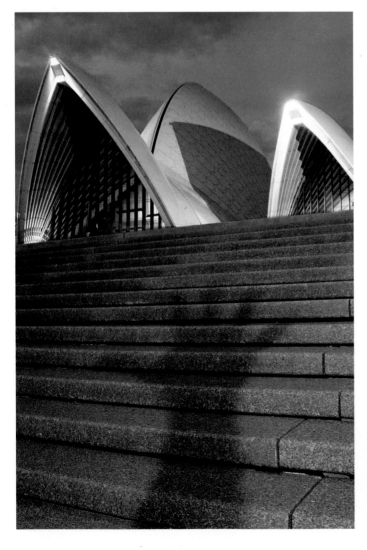
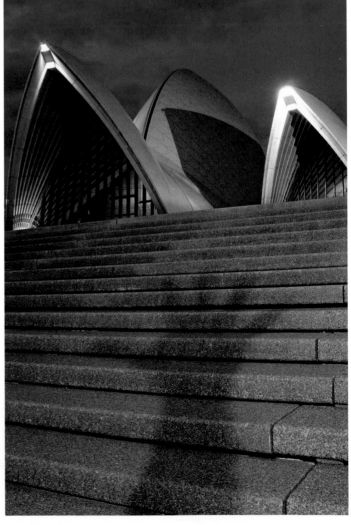

DURING ONE WORKSHOP I PUT TOGETHER this "timeline" of four different shutter speeds and their relationship to correct flash exposure. As you look at these shots, it's easy to see a clear distinction between each one: The brightness of the sky and the subject (the ambient exposure) decreases from the first composition to the last, yet the foreground flash exposure of my hand's shadow and the steps remains the same in all four.

How is this possible? As we've learned up to this point, a correct flash exposure is 100 percent under the control of the right aperture choice. The correct aperture choice is always dictated (1) by any depth of field concerns you may have, (2) by the flash-to-subject distance (determined by you), and (3) by adjusting the power settings on your flash. A correct ambient exposure, when combined with the use of flash, is 100 percent under the control of the shutter speed—and these four examples really make that point.

With my camera on tripod, I first determined that this scene required a great deal of depth of field, so I chose f/22, and before I even pulled out my flash, I pointed my lens to the sky and adjusted my shutter speed until 2 seconds indicated a correct exposure. I then quickly arranged my composition, and although the steps were really faint and hard to see, I didn't worry since I was about to light them up with my flash. With the flash at full-power (1/1) and at an aperture setting of f/22, I got a flash-to-subject distance of 9 feet. One of my students held the flash about 1 foot behind my raised arm, and I quickly made the four exposures you see here, changing the shutter speed 1 full stop for each one. All were shot at f/22, which is why the flash exposure is correct and constant, but note the change in the ambient light of the building and sky: After the first exposure of f/22 for 2 seconds, I shot the next at f/22 for 1 second, then the next at f/22 for 1/2 sec., and finally the last at f/22 for 1/4 sec. It's pretty clear that the role of shutter speed in flash photography is meant to do one thing: control the exposure of any and all ambient light. You get to decide how much or how little ambient light gets exposed—assuming, of course, that you're shooting in manual exposure mode or engaging your autoexposure overrides when shooting in Aperture or Shutter Priority mode.

All photos: 16–35mm zoom lens, f/22, Speedlight SB-900. Opposite, left: 2 seconds. Opposite, right: 1 second. Below, left: 1/2 sec. Below, right: 1/4 sec.

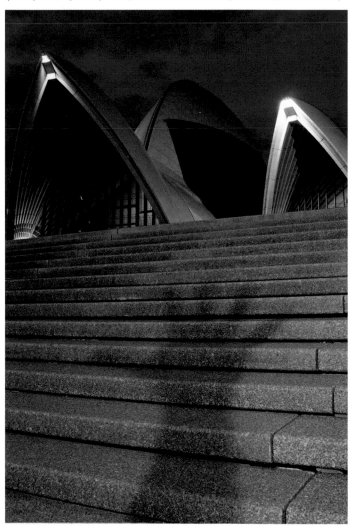

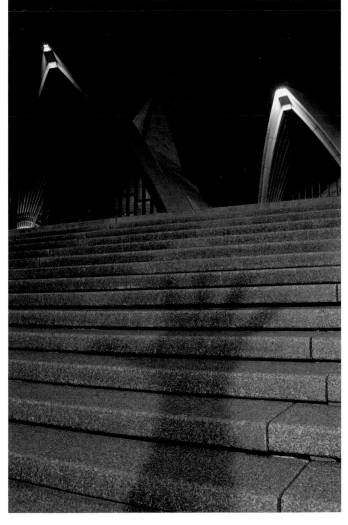

maintain your ability to control the amount of natural light that exposes the scene with your shutter-speed choice. The longer your shutter remains open, the more ambient light you allow in your exposure (after the flash has fired), making it lighter; the shorter your shutter remains open, the less ambient light you allow in, making the exposure darker.

When you use flash, you now have *two* light sources: the ambient light *and* the supplemental light from your electronic flash. Simply put, controlling the ambient light is a task assigned to the shutter speed; controlling the flash exposure falls to the aperture. So again, aperture (*f*-stop) controls the *amount of flash light* allowed to reach your camera's digital sensor (or the film); shutter speed controls the *length of time the ambient light* is allowed to strike the digital sensor (or film).

How does this affect your photographs? Changing your aperture to make your lens opening bigger or smaller and control the brightness of your flash (i.e., the amount of flash light that reaches your sensor) primarily affects the main *subject* and anything else within the flash range (see page 58 for more on flash range). Changing your shutter speed to control the amount of time that ambient light hits your sensor primarily affects the *background* and any

surrounding elements that are outside the flash range. The *slower* the shutter speed, the *brighter* these elements will be; the *faster* the shutter speed, the *darker* these elements will be.

Now fast-forward to your son's next birthday party being held in the basement of your home. You take a picture with the flash set on manual and at full power, and let's say the aperture is set to *f*/11. You quickly see that the subjects in the picture are too dark, so you open your aperture to *f*/8. This bigger hole now lets in more light, and voilà, it's better. Or perhaps the picture you took at *f*/11 was too bright, so you stop down the lens to *f*/16 and take another, and again get a much better exposure. At no time did you change your shutter speed. The flash exposure of your subjects was 100 percent controlled by the right choice in aperture.

In the same scenario, if the subjects were well exposed but the background were too light or dark, then you're probably not getting the right amount of ambient light in your exposure to illuminate the full composition beyond the subjects. To fix this problem, you would adjust your shutter speed up or down to let the ambient light strike the camera's sensor (or the film) for the appropriate length of time.

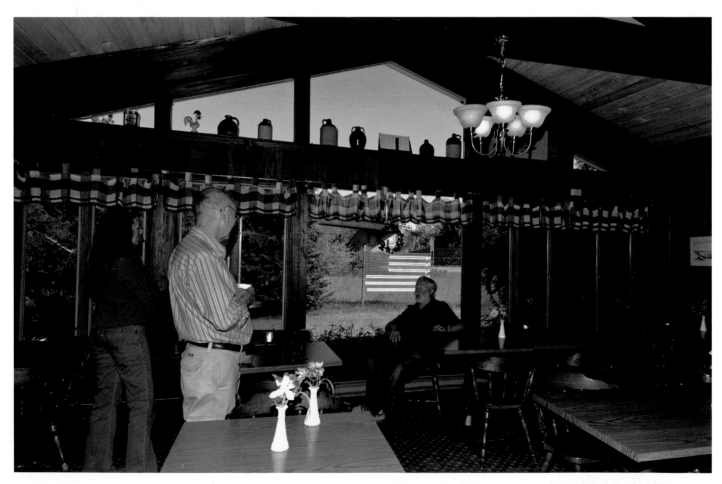

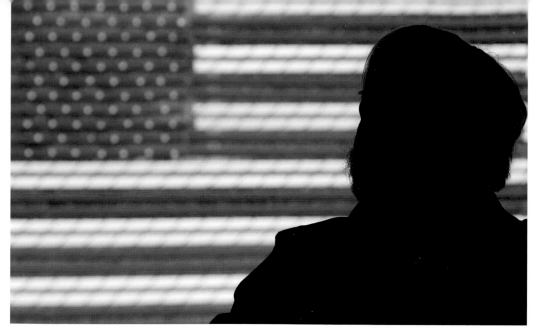

WHENEVER YOU COMBINE FLASH *with ambient light, you always have the option of manipulating the ambient light (making it darker or lighter) by adjusting your shutter speed. Here, my friend John was sitting in a small, interior dining area (opposite). Outside and behind him, the Stars and Stripes had been woven into a cyclone fence. When I checked the distance scale on the back of my portable electronic flash, it indicated an aperture of f/11 to render a correct flash exposure of my subject. This setting was based on the distance between John and the flash (which I had set on a nearby table). With the aperture set at f/11, I adjusted my shutter speed until the camera's light meter indicated 1/125 sec. as a correct exposure for the bright, frontlit flag. But I decided to not turn on the flash for the first exposure (top). I simply shot the ambient-light exposure. As you can see, this resulted in a perfect exposure of the flag; however without any flash, John was a stark silhouette because the ambient-light levels surrounding him were nowhere near as bright as the light outside shining on the flag.*

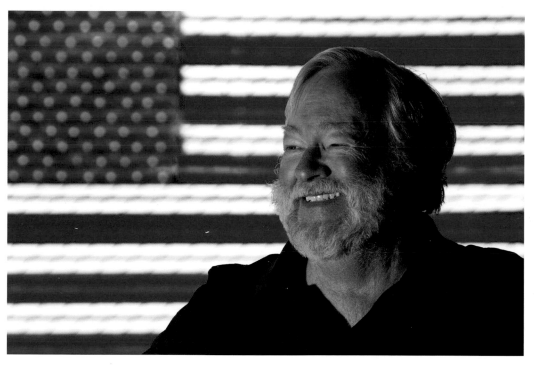

If I want to render the flag darker, I underexpose it 1 stop by shortening my shutter speed to 1/250 sec. (center). To render the background lighter, I overexpose it 1 stop by lengthening my shutter speed to 1/60 sec. (bottom). As you can see, the background in those shots has changed, yet the flash exposure on John's face remains correct and constant. Why? Because the shutter speed controls only the ambient light, and the aperture controls the flash. Since I only manipulated the shutter speed and not the aperture, the flash exposure on John's face remained the same. Simple enough, right? If my hunch is correct, this is one of those "aha!" moments in your journey toward understanding electronic flash.

Top: f/11 for 1/125 sec. Center: f/11 for 1/250 sec., Speedlight SB-900. Bottom: f/11 for 1/60 sec., Speedlight SB-900

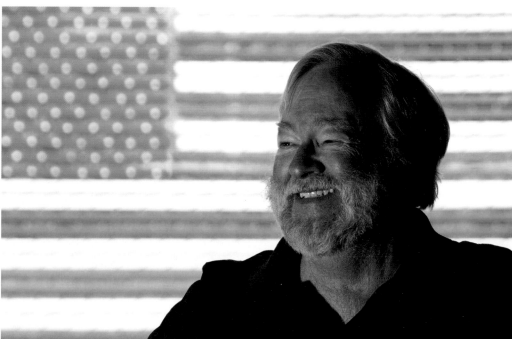

MANUAL FLASH
EXPOSURE

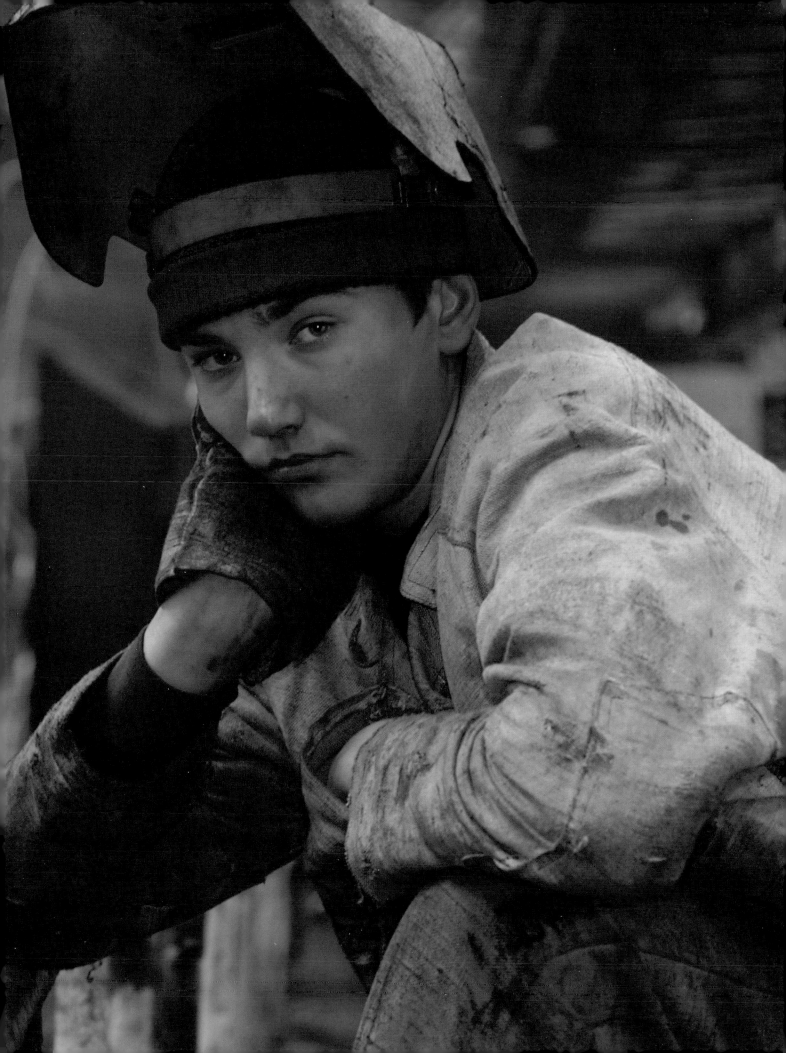

Manual Mode and the Distance Scale

There was a time, back in the late 1950s and early 1960s, when flash photography was a completely manual operation. A correct flash exposure was 100 percent dependent on the use of the right aperture for the corresponding flash-to-subject distance. Flashes came with handy charts listing the best aperture based on the flash-to-subject distance. You simply located your ISO and flash-to-subject distance on the chart, and there was the preferred aperture!

Today, as you've just seen in the first chapter, a correct flash exposure is *still* 100 percent dependent on the use of the right aperture for the corresponding flash-to-subject distance. Now you might think the electronic-flash industry is living in the dark ages, but the fact is that the electronic flash has come a long way, delivering far more sophistication and much more power than were available back in the '60s. One exciting example of this is that most of today's flashes have an *automated distance scale*. You tell the flash what aperture you want to use, and based on your ISO, the automated distance scale tells you the exact distance your flash needs to be from the subject to record a correct exposure. Conversely, you can plug in your ISO, determine your desired distance from flash to subject, and the automated distance scale will tell you the correct aperture. Set that aperture on your lens, and you're good to shoot! If this isn't the aperture you wish to use, either increase or decrease your flash-to-subject distance until the scale indicates the aperture you want.

If you know my book *Understanding Exposure*, then you're already familiar with my insistence on learning how to shoot a daylight exposure in manual exposure mode. Many of you have reported to me just how liberating that was and how it opened up an entirely new and far more creative world of photography. You also reported—with tremendous enthusiasm—just how darn easy it was. Well, learning to shoot a manual *flash* exposure is just as easy.

If you're not sure how to set your flash to manual exposure mode, get out your flash manual, and look it up. (I've put together a series of short video clips describing how to set many of the more popular flashes to manual mode. Visit www.ppsop.com/manual flash.axp to see if your flash is there.) You also want to set your camera to Manual mode. If one of these devices remains on Auto or Program, your camera might default to a much slower shutter speed to account for low light levels in your scene.

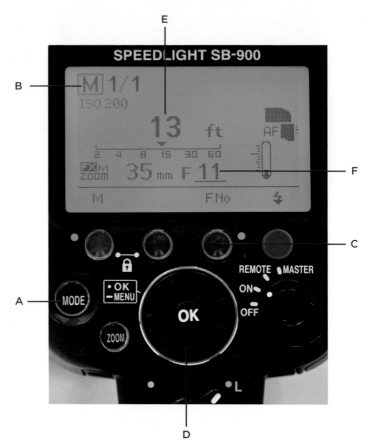

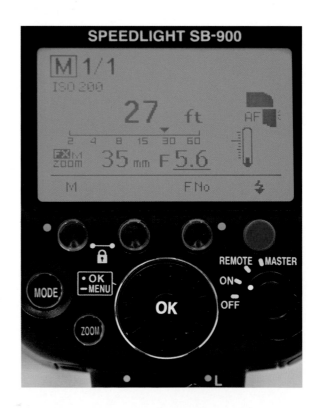

TO MAKE THIS FLASH *exposure of my daughter Sophie at a distance of 13 feet, I used the flash distance scale to determine the correct aperture for my flash-to-subject distance. Pressing the mode button (marked A in the top image on the opposite page), I set the flash mode to Manual, indicated by the letter M (B). I've now assumed full control of the flash. Since I've determined the flash-to-subject distance is 13 feet, I then set the flash distance to 13 feet by pressing the aperture selection button (C) and then turning the wheel (D) until 13 feet shows on the distance scale (E).*

(Turning the wheel clockwise causes the distance scale to indicate a shorter flash-to-subject distance and a correspondingly smaller aperture. Turning the wheel counterclockwise causes the distance scale to indicate a greater flash-to-subject distance and a correspondingly larger aperture, as pictured in the bottom image on the opposite page when I turned the dial all the way to 27 feet and the correct aperture became f/5.6.)

Once the distance scale reads 13 feet, the flash's display indicates a necessary aperture of f/11 (F). So that means the amazing computing power of my flash just told me I need to use an aperture of f/11 to record a perfect flash exposure of a subject that's 13 feet from the flash. (Note that the flash was mounted on the camera's hot shoe for this shot.)

Nikon D300S, 24–85mm lens, ISO 200, f/11 for 1/100 sec., Speedlight SB-900

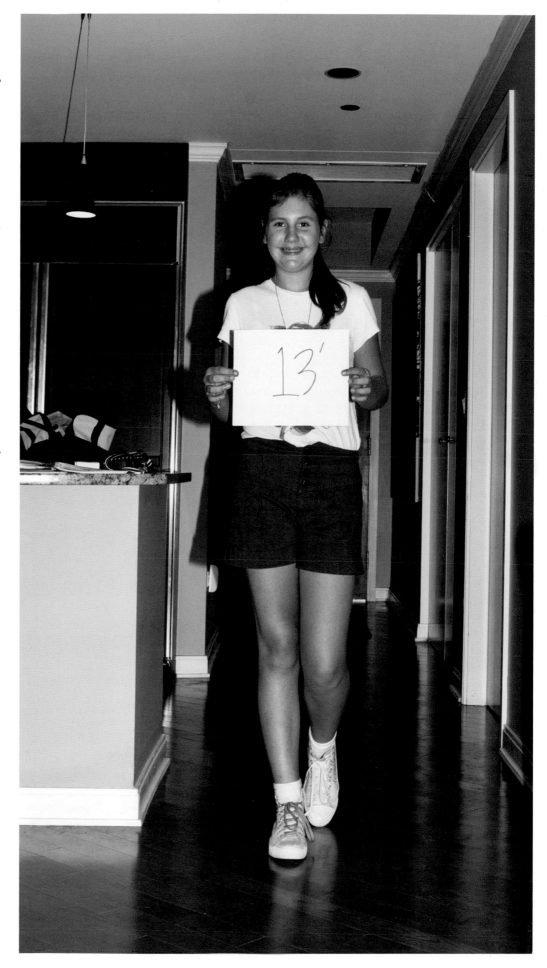

Now it's time to grab your camera, flash, and a willing subject—maybe a person, animal, or that proverbial vase of flowers on the table. With your camera and flash in Manual mode, set your camera's shutter speed to 1/100 sec. (Note that it doesn't matter whether you have a built-in pop-up flash or an external portable electronic flash, as long as you have it set to Manual flash exposure mode.) Then stand at a distance of 13 feet from your subject. Turn the wheel (or it may be buttons, depending on your flash make and model) on the back of your flash until 13 feet shows up on the distance scale (like you see in the display on page 34). If your flash doesn't show exactly 13 feet, no worries; just pick the distance closest to 13 feet (12.3, 12.7, 13.4, or whatever it may be).

Note the corresponding aperture for the distance of 13 feet, and set that same aperture on your lens. Then simply focus and shoot. Voilà! You just shot a perfect flash exposure of your son, daughter, wife, husband, dog, cat, neighbor, cousin, uncle, grandma, or vase of flowers. This was no fluke! Pretty cool *and* easy to do, eh? I'll say it again: *Perfect flash exposure has always been—and always will be—about choosing the right aperture for the corresponding distance between the flash and the subject.*

(Keep in mind that this perfect exposure is of the main subject only. You may not be particularly fond of the contrast between the subject and the background, much like what you see in my shot at right. Don't worry about that right now; I'll get into proper exposure of background elements later.)

And this simple process also works the other way, especially when you're free to move closer or farther away from your subject: If you have a specific aperture you wish to use—because of depth of field concerns, for example—you can set that aperture on your lens, plug the same aperture into your flash's distance scale, see the suggested flash-to-subject distance necessary for a correct exposure at that aperture, and simply move to that distance from your subject. Consider again the example shown here, where the subject was 13 feet from the flash. My Nikon Speedlight SB-900 suggested an aperture of *f*/11 for this distance. But let's assume I want a lot of depth of field in my image and, therefore, set the lens aperture to *f*/22. Correspondingly, I'd also set the *f*-stop on the flash distance scale to *f*/22, and in turn, the distance scale tells me that to achieve a correct exposure of the subject at that aperture I'd need a flash-to-subject distance of 6 feet. So if the flash is mounted on my camera, I move to a spot 6 feet from the subject, or if the flash isn't on camera, I move the flash to a spot 6 feet from the subject, and then I'm free to use *f*/22.

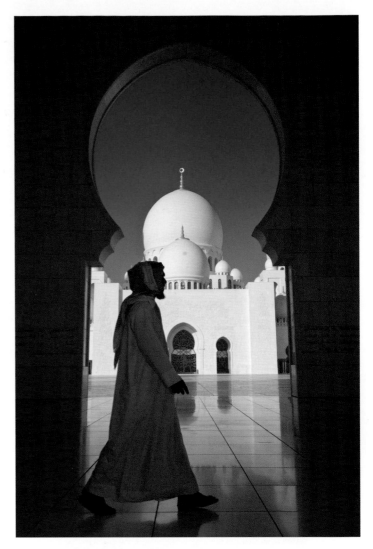

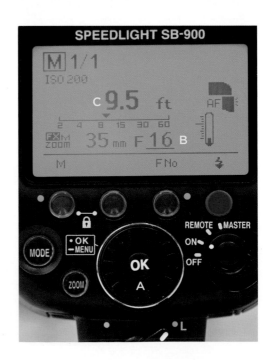

NOW THAT YOU'VE SEEN HOW *easy it is to set a manual flash exposure, let's do it again—but this time in combination with outdoor ambient light. The first step is to determine the correct shutter speed for the ambient light only. In my first image (opposite), I metered exclusively for the natural light before me. I knew I wanted somewhat substantial depth of field, so I set the aperture to f/16, and taking a light-meter reading from the blue sky ahead of me, I determined that the correct shutter speed for f/16 would be 1/200 sec. Not surprisingly, Yousif, my subject, recorded slightly silhouetted, since he wasn't walking in the area lit by the sun; only those areas lit by the sun recorded as a correct exposure.*

To bring Yousif "into the light," I called on my "miniature sun." Since I wanted to stick with f/16 for depth-of-field reasons, I already knew the correct shutter speed for the ambient light was 1/200 sec. To add flash and correctly expose Yousif, the only thing I needed to determine was the correct flash-to-subject distance. I rotated the dial (A) on the back of my Nikon Speedlight SB-900 and saw that for f/16 (B) the subject should be 9.5 feet (C) from the flash. I estimated that Yousif was around 10 feet from the camera—close enough. I instructed Yousif to walk through the scene once more, and when I exposed the image again at f/16 for 1/200 sec., the flash also fired, illuminating him while still maintaining a correct exposure of the surrounding elements.

So to recap: I determined the correct exposure for the daylight, used that aperture to find the correct flash-to-subject distance, positioned the flash appropriately, and took the shot using the original exposure plus the flash. Are we having fun, or what?

Both photos: Nikon D300, 12–24mm lens at 24mm, ISO 200, f/16 for 1/200 sec. Right: with Speedlight SB-900

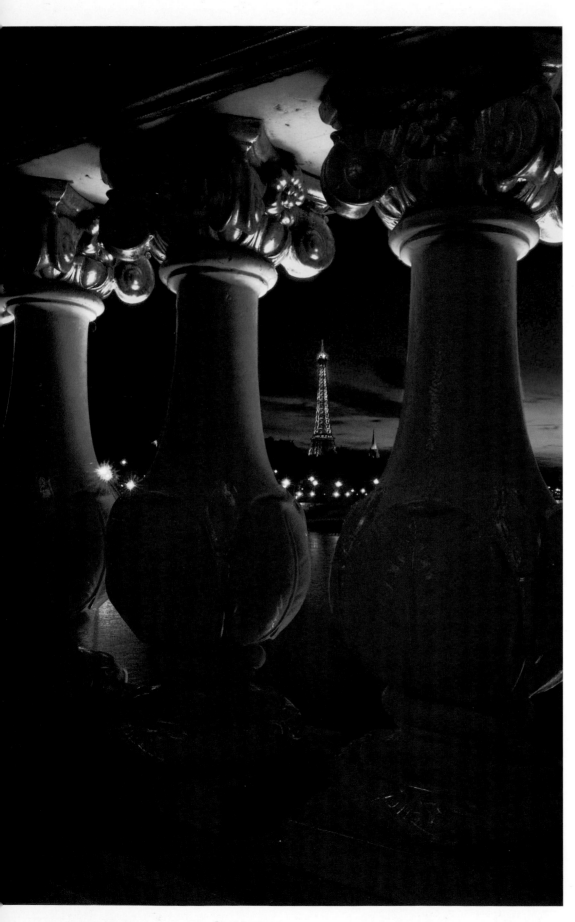

AS EASY AS THAT LAST
*example was, let's look at
another in which, once again,
I combined the ambient light
with the flash's light for a
perfect exposure. For this one,
I set up low to the ground
on the Alexandria Bridge in
Paris, anxious to frame the
distant Eiffel Tower through the
balustrade lining the bridge.
Without the benefit of flash
(left), I was able to record a
nice exposure of just the
ambient light in the scene.
(Since I wanted a large angle of
view and great depth of field, I
used my 16–35mm lens and f/22,
presetting my focus at 1 meter
into the scene via the distance
scale on the lens, and simply
adjusted my shutter speed until
4 seconds indicated a correct
exposure.)*

*For the image on the facing
page, nothing changed in my
exposure settings; I still was at
f/22 for 4 seconds. But clearly,
something has happened—
and that something was the
simple addition of flash. Using
the flash's distance scale, I
determined that at f/22 the
flash set at 1/2 power would
need to be about 4 feet from
the subject (the balustrade) to
record a correct flash exposure.
I then simply held the flash in
my left hand about 4 feet from
the balustrade columns and
fired the camera with my right
hand. The columns were then
illuminated, while at the same
time, the ambient exposure of
the other areas of the scene was
maintained.*

*Both photos: 16–35mm lens
at 16mm, f/22 for 4 seconds.
Opposite: with Speedlight
SB-900*

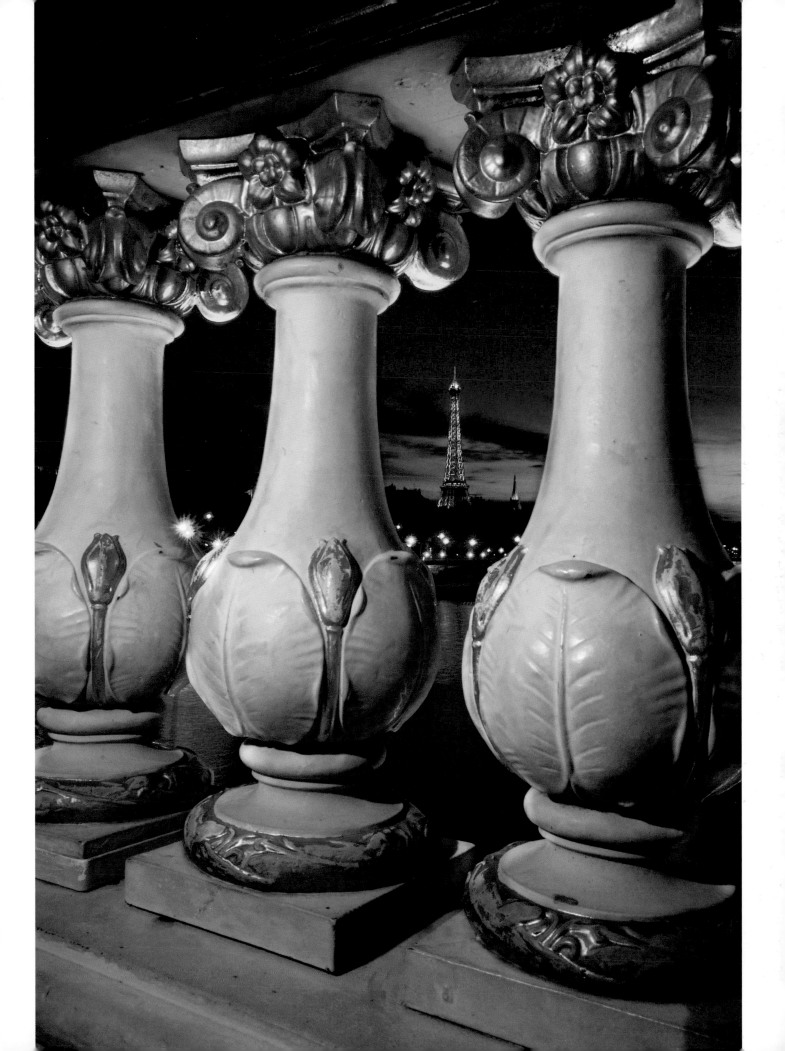

Powering Down the Flash

If you've never messed with your flash's power settings, then chances are really good that the unit is at full power, since all flashes are shipped from the manufacturer with the default setting of full power in place. A full-power setting is typically indicated as a fraction of 1/1 on the flash's display screen. If you play around with the power settings, you'll quickly see that you can change this fraction and the corresponding flash power output. So 1/2 would indicate you've *powered down* the flash to half its full-power output, for example; 1/4 would indicate one-quarter power output; and so on all the way down to possibly 1/32, 1/64, or even 1/128, depending on your flash. Each of these fractions represents the fraction of the full-power output. Too many photographers think that powering down is something you only do when you don't want the flash to overpower the subject, as in a simple portrait for which all you need is a bit of fill light to reduce the raccoon eyes, for example. However, powering down can also be much more useful than that—it gives you freedom of movement.

What exactly is going on when you mess with the power settings of your flash? Simple math tells you that you're cutting down the flash power, and simple math is right. At full power (1/1) and with ISO 200 and a subject at a distance of 16 feet, the flash tells me I'll need to use *f*/11 to record a correct flash exposure. If I reduce the power to 1/2 (half-power), what happens? Take a look at the distance-scale readouts on page 42. Assuming I keep an aperture of *f*/11, the flash now indicates a flash-to-subject distance of 11 feet.

It's pretty simple to see what's happening: The more you power down your flash, the closer the flash must be to your subject to maintain a correct exposure. Trust me, there are many subjects you'll want to place the flash closer to. With the flash at full power, many of those subjects would be way overexposed, since the flash is putting out too much light based on its distance to the subject. Fortunately, by powering down the flash, you can still come away with a perfect flash exposure, even when working at seriously close distances.

Think of this analogy if it helps you: Assume for a moment that your flash at full power (1/1) is a 1-gallon

bucket of water, and the subject you want to douse with this gallon of water is 15 feet away. Press the shutter on your camera, and whoosh! Your subject is now soaking wet from the gallon of water. If you set the flash to half-power (1/2), it's like you're swinging the gallon bucket with only half the strength. The water will still come out, but it'll only travel half as far. So at half-power you must move in closer if you want your subject to be doused by the full gallon of water. When powering down, as long as you move your flash closer to the subject as indicated by the distance scale, your subject will still get the full flash intensity—that entire 1-gallon dose of water.

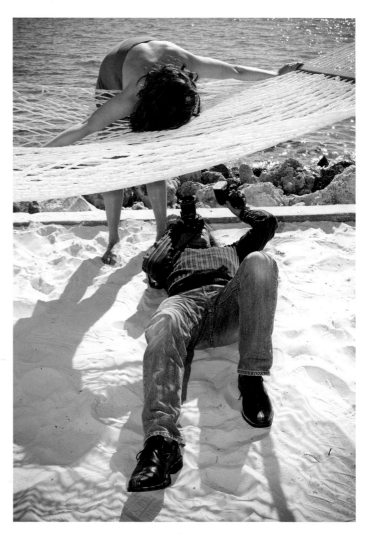

ON A BEAUTIFUL, SUNNY day around 2:00 PM during a workshop in Tampa, I noticed our model, Deana, lying in a hammock during a break. This sparked an idea, and lying underneath the hammock, I prepared to photograph upward as she looked down at me, framed by the many ropes of the hammock (opposite). However, the resulting available-light exposure of f/11 for 1/125 sec. was quite flat. The sun was still high in the sky, just to her left from this shooting angle, which explains why there wasn't any light on her face. I could have used a reflector, placed right on top of me to reflect the sunlight up onto her face, but the intense light would surely have caused her to squint, and this was not the time to shoot a "squinting portrait."

A more favorable option was to call on portable electronic flash. I wanted to replicate the warmth and color of low-angled light on a late-afternoon summer day, so I also placed an amber gel on the flash. (This affected my flash-power setting in this scenario, but I'll get into that topic later on page 138.) I quickly realized that I'd need to power down my flash, because I was very close to Deana—about 18 inches, in fact. I wanted to use an aperture of f/11, the critical aperture at which both sharpness and contrast reign supreme. So with f/11 set on my lens and flash, I began to dial down the power until I saw that 1/128 power would give a correct flash exposure at my flash-to-subject distance of 18 inches. Since I wanted to replicate a low-angled sun, I also chose to hold the flash about 20 inches to my left, creating low-angled sidelight. As you can see, I achieved my goal.

Both photos: Nikon D300S, 12–24mm lens at 24mm, ISO 200, f/11 for 1/125 sec. Bottom, right: with Speedlight SB-900

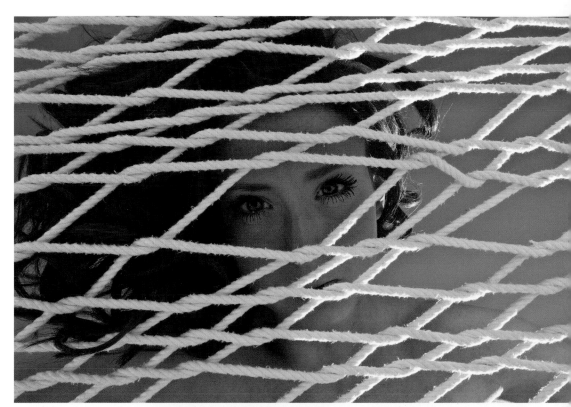

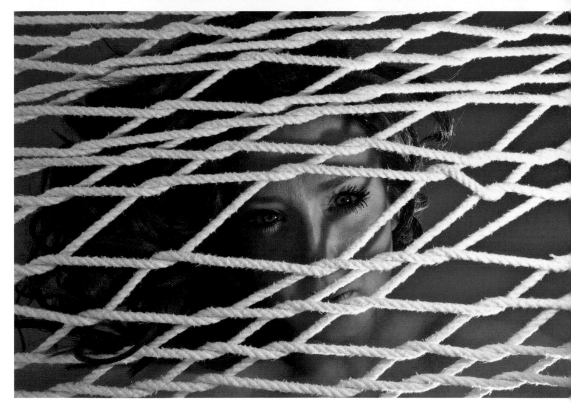

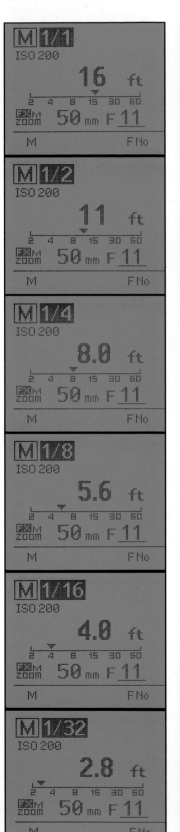

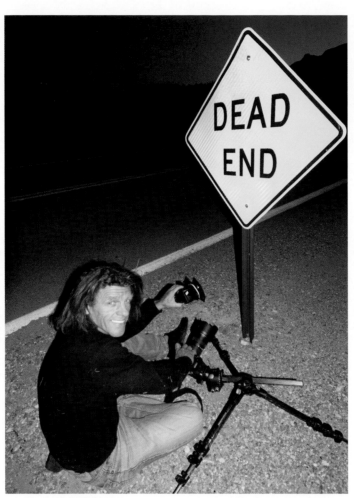

POWERING DOWN & THE DISTANCE SCALE

At left you're seeing various shots of the display screen on the back of my Nikon Speedlight SB-900. Take a look at how the required flash-to-subject distance displayed by the distance scale gets *smaller* as I power down the flash output. The mode (M for Manual) and the power-output fraction are in the upper left corner of each screen. In the top readout, that fraction is 1/1, indicating that I'm at full power, and the necessary flash-to-subject distance is 16 feet. Reduced to 1/2, that flash-to-subject distance shrinks to 11 feet. If I reduce power from 1/2 to 1/4, the flash indicates I can achieve a correct exposure only if my subject is 8 feet from the flash. At 1/8 power, it's 5.6 feet. At 1/16 power, 4 feet. And finally at 1/32 power, a correct exposure requires a flash-to-subject distance of 2.8 feet. It's a clear illustration of the relationship between power output and flash-to-subject distance.

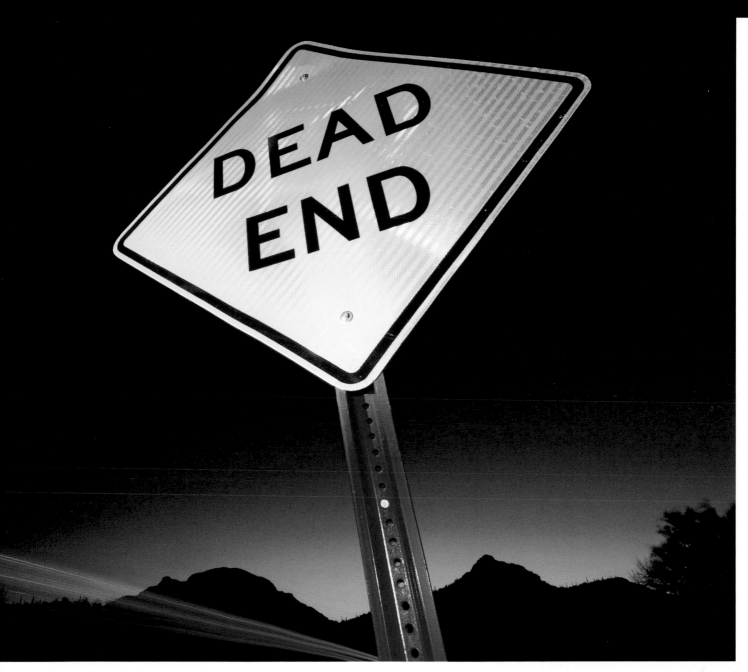

FOLLOWING A WORKSHOP I TAUGHT IN TUCSON, *two students, my assistant Wayne, and I ventured out for an unscripted evening of shooting. Searching for the perfect cactus-laden desert landscape, we instead came across a dead-end sign that faced a mountain range as we headed west. The sign spoke to me. All it needed was a bit of light to make its voice heard.*

So I grabbed my camera, tripod, and two of my Nikon Speedlight SB-900 flashes. Choosing a low-angled position, and shooting upward and close to the sign, created a point of view that elevated the sign to a stature of supreme importance, especially when combined with both ambient light and the light from a couple of flashes.

I decided I wanted passing red taillights heading into the dead end up ahead, so I asked Wayne to drive our van into the scene during my exposure. Since I wanted taillight streaks, I needed an exposure time of at least 4 seconds. These 4 seconds would allow the taillights to streak across the entire composition as Wayne drove through the scene. So with ISO 200 and the shutter speed set to 4 seconds, I metered off the dusky blue sky and adjusted my aperture until the camera's light meter indicated f/11 for a correct exposure.

This, of course, was the correct exposure for the ambient light. Since my ambient exposure relied on the aperture of f/11, I was committed to using that same aperture for the flash exposure. With both of my flashes set to Manual, their distance scales indicated

a flash-to-subject distance of about 11 feet for a full-power (1/1) exposure at f/11. That just wasn't going to happen, since I had every intention of staying close to this road sign. As I powered down both flashes, I found that at 1/32 power at f/11, the flash-to-subject distance was now 2 feet. Perfect!

I placed one flash on the ground, pointing it up at a slight angle toward the gray post. I also placed a red gel on this flash to turn the gray post blood red. (Don't let my use of a red gel here throw you off; even without it, my setup for this shot wouldn't have been any different, and I'll talk about the use of gels more on page 138.) I held my other flash in my left hand, off to the left of the sign. And since I was introducing motion into this scene, I set the camera to rear-curtain sync. Most flashes fire at the beginning of an exposure, but with rear-curtain sync, the flash doesn't fire until the end of the exposure, which is what I needed here with the extended shutter speed and going for taillight streaks. (See page 102 for more on rear-curtain sync.)

At this point I signaled to Wayne, who was waiting on the road about 10 feet behind me. Just before the van entered my composition, I tripped the shutter release, and 4 seconds later, this image was the result.

Nikon D300S, 12–24mm lens at 12mm, ISO 200, f/11 for 4 seconds, Speedlight SB-900

Manual vs. TTL Flash

In the late 1960s, Honeywell came up with automatic flash, thus eliminating, in theory, the need to readjust the aperture every time someone moved from the distance for which the flash was set. Eventually this automatic flash concept was further developed into what is today known as TTL (through-the-lens) flash, initially introduced with great fanfare by Olympus back in the '70s. Today's flashes are even more sophisticated, most using E-TTL (evaluative through-the-lens), while Nikon now has i-TTL (intelligent through-the-lens). And to be clear, TTL isn't limited to portable flash. It's the "norm" for all of those built-in or pop-up flashes found on digital point-and-shoots and many DSLRs. Just as you can change the setting for TTL on a portable flash to Manual flash exposure mode, you can also change the standard TTL default setting to Manual flash mode on most pop-up and some built-in flashes.

TTL works on a simple premise of first sending out a "pre-flash"—an infrared beam or white light—that strikes your intended subject, travels back to the camera, and tells your flash's onboard computer how much flash power is needed to create a correct flash exposure based on the amount of light that comes back to the camera's meter. The pre-flash beam calculates the amount of light needed based on the light actually coming through the lens along with the subject-to-flash distance. The camera's onboard computer then adjusts the flash power based on the amount of light reflecting back into the camera. This pre-flash journeys out from near the flash head and returns so darn fast that you don't even know it happened. *What pre-flash?* Exactly.

Let's say you want to take a picture of your son, who's standing 12 feet away, and you're using an aperture of f/8. As you press the shutter button, the pre-flash zips out of your electronic flash, bounces off your son, and flies back to the flash unit to tell the onboard computer, Okay, Boss, here's the deal: We need to light a subject 12 feet away, and the photographer is using an aperture of f/8. The onboard computer makes a calculation based on these variables and tells the flash to put out exactly the right amount of power. To ensure even more accuracy, this pre-flash is metered at whatever you focus on.

Technology can be good, and for some, TTL flash technology is the greatest of all. If you're a professional wedding photographer, event photographer, photojournalist, or member of the paparazzi, operating in TTL mode makes perfect sense. You don't have to think about anything—just point and shoot. I'm all for TTL in some instances, but even the latest and greatest flash out there will become a useless tool if you don't know where to aim it and understand where the light is going—even when using TTL.

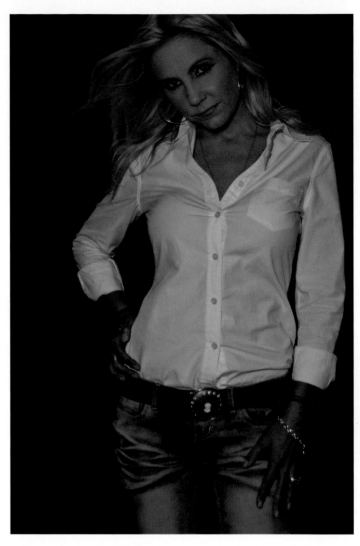

WHY DO I DISLIKE TTL? *Because it has a heck of time dealing with white or black subjects. Consider this example of my wife, Kate, standing in an alleyway against a black wall while wearing a white blouse. As you can see above, TTL flash mode produces an essentially underexposed result. In TTL mode, the flash powers down a bit automatically, limiting its light output, because it gets fooled by the white blouse. The flash attempts to make the white blouse gray, and it does a fairly good job, but since Kate's blouse is white, I want it to look white.*

When I switch to Manual flash exposure, I know, without question, that I'll record a perfect flash exposure, simply because the aperture I'm using corresponds to the flash-to-subject distance. Unlike TTL mode, in Manual mode there's no infrared beam that measures the reflected value and distance to the subject—and thus, no opportunity to record a bad exposure. The full power of the flash is realized, since I set the exposure, and unlike the TTL metering, the flash isn't being fooled by the white blouse. As the second example clearly shows, the correct flash exposure reveals a much more stunning Kate!

Both photos: Nikon D300S, 24–85mm lens, f/8 for 1/200 sec., Speedlight SB-900. Above: TTL mode. Opposite: Manual flash mode

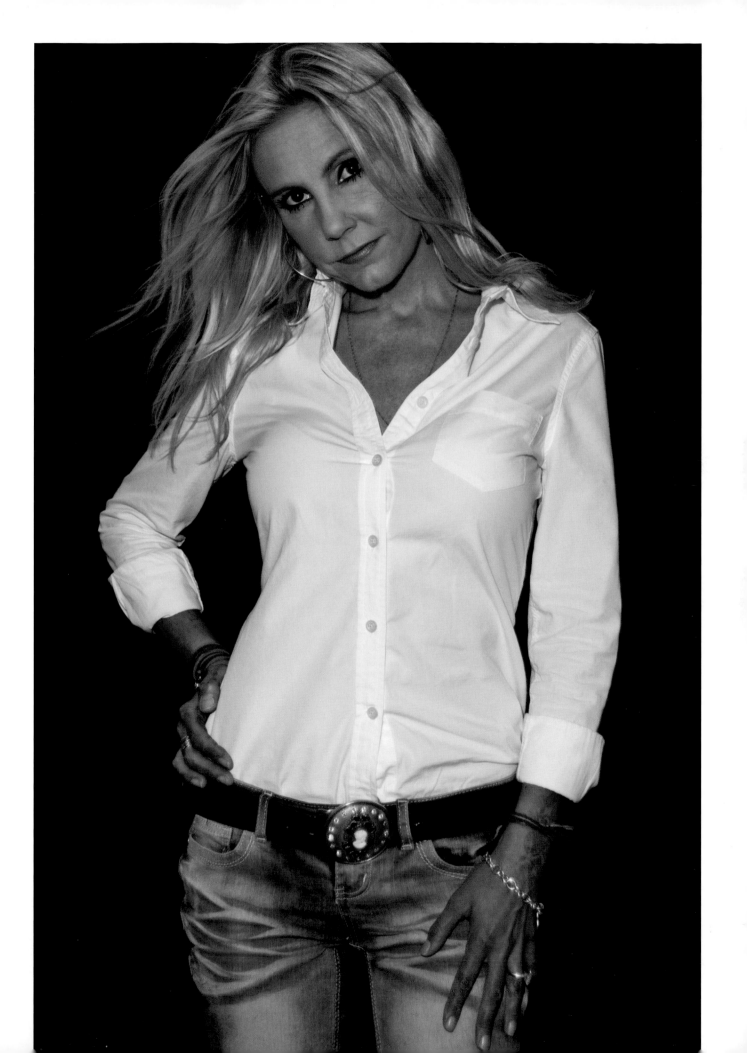

Let's examine the manual vs. TTL flash question a little deeper. The thought process usually goes something like this: Just use TTL flash, and it will take a perfect flash exposure every time. It does so without asking anything of you. No matter where you take are, no matter what your subject, no matter what time of day, just call on TTL! If you've spent any time in photo chat rooms, at camera clubs, or jawin' with other photographers at your local Starbucks, you are no doubt familiar with this argument. Well, guess what? This assertion just *isn't* always true. You can get perfect exposures in TTL, sure, but it requires some degree of input from you. The day of simply aiming, focusing, and shooting has yet to arrive. With TTL, we're really, really close, but manual flash exposure still provides the most control over your flash exposure in the widest variety of shooting situations.

Outside of the aforementioned wedding photographers, photojournalists, and paparazzi, there are but a handful of photographers who honestly understand flash so well that when they operate in TTL mode they can actually predict the outcome almost all of the time. I want to *know* what's going on with the camera and flash *before* I shoot. I want full control, from start to finish, of both my exposure and composition. My deliberate manual mentality carries over to my use of flash. I have deliberately set my flash to Manual mode, and for the most part, it never leaves this parking spot. I know, just about every time, what the flash is going to do, where it's going to go, what it's going to light, and how the light will be shaped before I press the shutter release.

Since I'm a fair guy, I must be fair to TTL and describe where I think it's most useful. While it does take some time—albeit just seconds—to establish a proper manual flash exposure, it takes even less time to use TTL. If you have a moving subject, for example a speed walker heading straight for you on the sidewalk or the airborne boy opposite, the distance from subject to flash is constantly changing. Unless you can function at warp speed, it will be a challenge, if not impossible, to keep up with evaluating the flash-to-subject distance and then spinning the aperture dial quickly in an attempt to provide an accurate manual flash exposure. By the time you calculate the distances and settings, they will have changed. In this case, TTL allows you to just pay attention to the moving subject and concentrate on framing and composition. You have to make the choice that works best for you, which may be manual flash for some subjects and TTL for others.

The reason I usually choose manual is that, while today's flash units are highly advanced, the TTL metering can still

be fooled. Alternatively, when you work in manual flash and adjust your settings correctly, your exposures are perfect every time. Here's an example: Let's say your neighbor's cousin asks you to photograph his summer wedding. After doing some group portraits, you switch your camera to TTL so that you can circulate through the reception, capturing candid moments of moving subjects. A few moments later, however, the bride returns and grabs you for one more portrait. As she poses in front of the white wall with her flowing white gown and her three nieces, also in white dresses, you click away. But when you check the results, you flinch at what you see. Each of those frames is dark and gray, indicating an "under-flashed" exposure.

What happened? TTL metering was fooled by all the white in the scene (the white wall and white dresses). With TTL, all faith is placed in the flash's ability to meter the light *reflected back* off the subject. Because white is highly reflective, when the pre-flash bounced back to the camera, it indicated a higher-than-actual amount of light, causing the flash meter to say "enough flash" and prematurely stop the flash, resulting in an under-flashed picture.

The opposite problem can occur with dark subjects. Take the groom and all the groomsmen and position them in front of some dark burgundy curtains, and the TTL flash metering may very well be fooled again. Those black, light-absorbing tuxedos may not bounce back enough light to the flash metering system, so the flash thinks it needs to send out extra light to brighten up the dark subjects. This results in "over-flashing" the groom and groomsmen, which renders those black tuxedos gray instead of their true shade.

As simple and easy as TTL is to use, you now understand my preference for manual. Manual flash mode takes a little more thinking and some simple math (estimating the distance between the flash and the subject), while TTL is quick and easy but a little less reliable. The choice is now yours!

TO ASSURE YOU THAT I'M NOT TOO SET IN MY WAYS, *I'll admit that I have used TTL flash both indoors and outdoors. And this shot is one example of the latter. While at a skate park in New Zealand, I found kids everywhere, zooming past me at varying distances and speeds and making repeated jumps with their scooters and skateboards. With my aperture set to f/11, TTL told me, Don't you worry about a thing, Bryan! We know you're at f/11, and as you can see on the distance indicator, as long as you shoot subjects that are within 2 and 10 feet, we've got you covered!*

I took around fifty shots over the course of the next 10 minutes, but none was more satisfying than this.

Nikon D300, 12–24mm lens at 24mm, ISO 200, f/11 for 1/80 sec., TTL mode

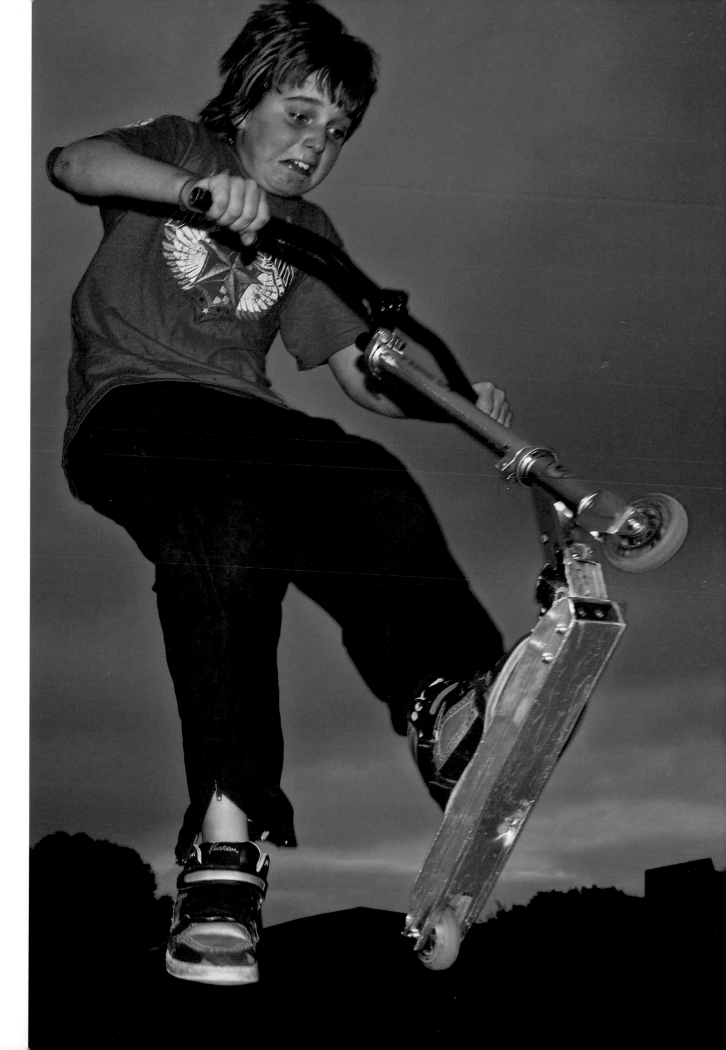

I DO ON OCCASION SHOOT
*in TTL mode. On one crisp fall
afternoon in Chicago as my
daughter Sophie played outside
with her friend Orion, I noticed
the strong backlight around
Orion's hair. With my lens at a
focal length of 200mm and the
flash head set to 200mm (see
page 118), I fired up the flash
and set it for TTL. Since I wanted
to render the background trees
as out-of-focus tones, I chose
an aperture of f/5.6 for shallow
depth of field and adjusted
my shutter speed until 1/200
sec. indicated about a 2-stop
underexposure for the natural
light reflecting off Orion's face.
As you can see at left, her face
was still a bit too dark.*

*I could have simply changed
my shutter speed from 1/200
sec. to 1/50 sec. and rendered
her face as a brighter exposure,
but in doing so, her naturally
backlit hair would have been
recorded as another full stop
overexposed (it was already
about 3 stops overexposed).
Also, the bright background of
out-of-focus leaves would have
been too bright. So what was
my option? Flash, of course.
With my flash mounted atop my
camera and covered with a small
diffuser, my flash's distance scale
told me that in TTL mode I could
take my picture at f/5.6 as long
as I wasn't closer to the subject
than 3 feet or farther away than
45 feet. Since I was about 15
feet away, I was well within the
TTL range, and as the image
opposite shows, a perfect flash
exposure resulted.*

*Both photos: 70–300mm lens
at 200mm, f/5.6 for 1/200 sec.
Opposite: with Speedlight
SB-900*

Flash vs. High ISO

You may have heard about the low noise and fine grain that you can expect when shooting with the high ISOs found on many cameras today. The argument suggests that you no longer need to use a flash because these high ISOs allow you to hand-hold your camera even in low light, using shutter speeds fast enough to capture properly exposed images with low noise. So when is it better to use a high ISO with natural light, and when should you use a flash?

Let's say you're at your child's basketball game in a gym illuminated by the typical artificial gym lights. I would never suggest that you try to light up your kid's basketball game with a flash. Instead, I'd suggest a much more logical solution: available light. If you're using a modern DSLR with ISO 6400 and your white balance on Automatic, at least initially, you'd find yourself shooting exposures at f/4 for 1/250 sec. At the end of the game, you'd not only have some great shots but shots that were far from being massively grainy, due to the low-noise capabilities of most modern cameras—and all made, of course, without an electronic flash. Taking advantage of these low-noise high ISOs is certainly not limited to the gymnasium. At indoor birthday parties, turn up

LIKE MANY PARENTS TODAY, I, too, am faced with photographic challenges that revolve around school activities, indoors or out, and many of those challenges and subsequent decisions involve the use or "non-use" of flash. However, when it comes to indoor volleyball and basketball—and, in some cases, even school plays—I am of the mind-set that one use the highest-quality ISO in lieu of flash.

Most gyms, and even stages, are lit well enough that recording acceptable handheld exposures is the norm with today's DSLRs. It's as if the camera manufacturers are in a constant race to see who can deliver the highest ISO without a truly noticeable drop-off in overall color, contrast, and distracting noise. In the photograph here, I found myself on the sidelines at one of my daughter Sophie's volleyball games. Handholding my Nikon D300S with my ISO set to 6400, I was easily shooting correct exposures at f/4 for 1/320 sec. with my 16–35mm Nikkor zoom. A no-brainer for me! If I had tried to light up this entire gym with my single Nikon Speedlight SB-900 flash, I would have been ensured of recording very cavelike exposures thanks to the Inverse Square Law.

Nikon D300S, 16–35mm zoom lens, ISO 6400, f/4 for 1/320 sec.

the lights in your house, set your camera to ISO 6400 and your white balance to Incandescent or Fluorescent, and with your lens aperture set at or near wide open, you're good to go.

One important thing to note: The low-noise, high ISO approach deals only with brightness levels. It provides little help for poor-quality lighting. Just because you can use high ISOs with shutter speeds fast enough to handhold doesn't mean you should always choose that option over flash. Here's why: The ambient light isn't always complementary to your subjects. High ISOs will not improve poor lighting conditions. If you're outside preparing to take a picture of your family at high noon, the sunlight will be directly overhead and create "raccoon eyes" on everyone. This effect can also occur indoors where the light source is straight above the subject. In this circumstance, you want to use flash in a fill-flash capacity to correct the poor light conditions by providing supplemental light on the faces that eliminates the raccoon eyes. (See page 70 for more on fill flash.) The low noise now seen with high ISOs is very useful, but it will never be a replacement for using flash to achieve better-quality lighting.

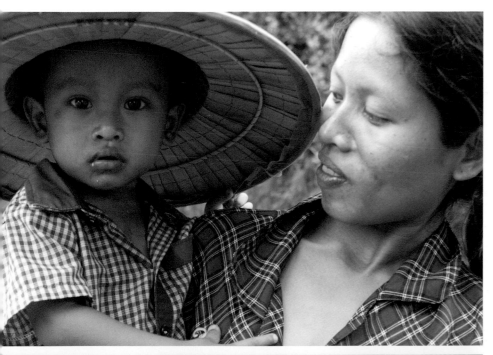

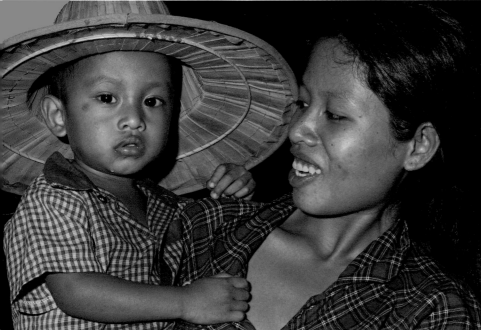

WHILE EXPLORING THE MANY SMALL *villages that surround the area around Angkor Wat in Cambodia, I came upon this mother and child. It was near dusk, the sun had been hiding behind some cloud cover for the past thirty minutes, and by the looks of the western sky, the clouds weren't in any mood to give the sun a final chance to cast its golden glow on the people and landscape before setting below the horizon. As a result, we found ourselves clearly in a very low-light situation.*

I could have just cranked up the ISO, but I thought I'd also try re-creating the look of low-angled sunlight with flash. If you compare the two options here, I bet you'll agree that flash is the winner. For the natural-light exposure (top), I handheld my camera and, with my ISO set to 1600, chose an aperture of f/8 and adjusted my shutter speed to 1/100 sec. With only ambient light (i.e., without flash), the light is flat, since the sun is well obscured by cloud cover. For the flash exposure (bottom), I again handheld my camera but set my ISO to 200. I was still using f/8, and since I wanted to kill what little ambient light was left, I also kept the shutter speed at 1/100 sec. (Note: f/8 for 1/100 sec. was the correct exposure for ISO 1600, but since I reduced the ISO down to 200, I was in effect recording a 3-stop underexposure of the ambient light.)

When I covered my flash with a light-amber gel, I found that at f/8 I needed a flash-to-subject distance of 3 feet with the flash set to 1/16 power. So I tethered the flash to the camera via a remote hot-shoe cord and held the flash in my extended left arm. I then fired away, and a much warmer, sharper, and colorful image resulted.

High ISOs are a great addition to your arsenal of photographic choices and should be called upon whenever flash cannot light up the entire necessary area or when the use of flash is either strictly forbidden or would get you "discovered" or would scare your subject. If none of these criteria apply in your shooting situation, however, don't let yourself get complacent; take the extra minute to set up your flash and flatter your subject while letting your peers also know that you are *indeed serious about photography!*

Both photos: 105mm lens, f/8 for 1/100 sec. Top: ISO 1600. Bottom: ISO 200, Speedlight SB-900

Using Pop-Up Flash

If you're serious about flash photography, you'll have far better results if you invest in a portable external flash, which is what I used for most of the images in this book. However, that doesn't mean pop-up flashes are totally useless; rather, you have to work within their limitations. One of those limitations is that pop-up flash isn't very powerful and is best suited for subjects that are 10 to 12 feet from the camera. In addition, if you're using a wide-angle lens zoomed out to its widest focal length, the top of the lens will partially obstruct the pop-up flash light, casting a shadow on the bottom of your picture.

The position of the pop-up flash is also limiting, because it sits right there on top of your camera, pointing straight out at the same subject you see through your lens. There's no ability to rotate or change angles to "bounce" the flash off a reflective surface. (See page 90 for more on this technique.) And this limited positioning and lack of mobility also contributes to the pop-up flash's frequent deer-in-headlights results. One way to dim your flash is to hold or wrap a small white tissue over it. You'll still see the deer-in-headlights effect but without the harsh, glaring results of raw, on-camera flash.

And I have to admit that when, on occasion, I forget my portable flash, the pop-up saves me from completely missing out on any photographic opportunities, as the images on pages 54 and 55 prove.

THAT DEER-IN-HEADLIGHTS LOOK *seen above is one of the most common outcomes when using pop-up (or even portable) flash indoors, and it's one of the reasons why most of us don't look forward to taking pictures indoors. But you can lessen this effect, whether indoors or out, with a simple fix: white tissues.*

That's just what I did as my family headed out to dinner on a recent vacation. The strong backlight of a setting sun will almost always require the use of the flash if you have a subject in front of that backlight that you want to illuminate. Remember, your camera's "vision" is more limited than yours (see page 14). Even though you can see both the setting sun and your subject, the camera's image sensor cannot. If you simply aim and shoot without benefit of flash, you'll get a silhouetted subject (opposite, top).

While pop-up camera flashes aren't ideal, if that's all you have available, you can still illuminate the scene. You just need to take one step to avoid or soften the deer-in-headlights, blown-out flash look: Cover the flash with a small piece of white tissue—a single layer will do—then trip the shutter release, and voilà! When I did this opposite bottom, the pop-up flash light was diffused as it passed through the tissue, creating softer foreground illumination of my daughter Chloë while still properly exposing her against the strong backlight of the setting sun.

Opposite, bottom: Nikon D300, 35–70mm lens, ISO 200, f/5.6 for 1/250 sec., TTL flash

WHEN GOOD FLASH GOES BAD:
ON-CAMERA FLASH LIMITATIONS

If you went out and bought a new flash—something above and beyond the pop-up that comes with your camera—you may have set about trying to fill an entire room up with light only to find it didn't work. How come? There are three reasons why your flash doesn't fill up an entire room: (1) Though often shocking to many shooters, flash is constantly at the mercy of the Inverse Square Law, which, as discussed on page 16, dictates that light falls off from its source, often before it reaches the subject. (2) The flash may not have the necessary power to light up most rooms in their entirety. And (3), when you shoot indoors, you're probably mounting the flash on camera and pointing it in the wrong direction.

This last one's important, so let's consider it in more detail: Firing your flash while pointing it directly at the subject will often result in something resembling a mug shot. If the person in your photograph were holding a sign with a booking number, the image could pass for a mug shot taken by your local police department. The cops are using a camera with—you guessed it—a pop-up flash or a portable flash mounted on the camera's hot shoe and pointed directly at the suspected criminal. I seriously doubt that you're striving to make everyone you shoot look like a hardened criminal, and therein lies the problem with on-camera flash (whether pop-up or portable).

It is one-dimensional, creates flat light that's harsh and filled with contrast, and rarely flatters the subject.

Learning how to power up or down your pop-up flash, or using the exposure compensation settings when in TTL mode, can help somewhat, but let's not forget that pop-up flashes are *always* pointed in the wrong direction and are therefore darn near useless for indoor photography. There, I said it. There's no reason to sugarcoat it. Facts are facts, and the fact is that, unlike a portable electronic flash that you can position and place just about anywhere, your built-in pop-up flash can never move from its perch atop your camera. This flash position, especially indoors, often leads to the deer-in-headlights type of flash picture—one in which the subject is overly illuminated, with dark shadows behind. That look is a direct result of combining the bright output of your flash with the darker ambient light in a room. The room may seem well lit to your eyes, but your flash doesn't "see" what you see. Your flash only knows how to do one thing: light up a subject in front of it with "daylight." Its primary goal is to make everything look lit by the sun. Your flash produces imitation daylight, and the lights inside of your house do their best but can't reach the same intensity, especially once the sun has gone down.

I MADE THESE SHOTS ONE SUMMER *when my nephew Tyler joined me for a day in Seattle's Alki Point neighborhood. As the afternoon progressed to dusk, I noticed the potential for one of those magical shots of a west-facing city skyline, realizing from experience that all that glass in the buildings would soon reflect the sunset colors in the western sky behind me. I knew I'd have no depth-of-field concerns, since everything was at the same focal distance, and metering off the dusky blue sky, I got a correct exposure at f/11 for 1/8 sec. Then I recomposed with the skyline as the main subject (opposite).*

About this time, Tyler was standing atop a nearby picnic table pretending to be a rock star onstage. How cool would it be, I thought, if I were to light him up with the Seattle skyline in the background? But when I reached for my Nikon Speedlight SB-900 flash, my heart sank. I had left it behind. Fortunately, the Nikon D300 camera has a built-in pop-up flash. Its power is certainly not that of the SB-900, but it can still play with the big boys as long as I help it along by moving closer to my subjects.

So with the flash popped up and set to TTL mode, I changed my aperture to f/4, because I wanted to set an exposure for the ambient light of the city and be able to handhold the camera. I found that f/4 let me use a shutter speed of 1/60 sec.—fast enough to handhold without risk of camera shake blurring the image. My flash distance scale indicated that f/4 would work for any subject within 4 and 10 feet. Since I'd already established that f/4 for 1/60 sec. was also the exposure needed for the distant dusky skyline, I knew I could safely record a flash exposure of Tyler while also recording a correct ambient-light exposure of the city behind him.

Opposite: Nikon D300, 28–70mm lens, f/11 for 1/8 sec. Above: Nikon D300, 28–70mm lens at 50mm, f/4 for 1/60 sec., TTL flash

BEYOND THE BASICS

Guide Numbers and Flash Power

Now that we've covered some of the basic principles of flash exposure and manual shooting with flash, let's delve into some of the mechanics behind your flash so that you can better understand how your portable electronic flash works (or what considerations you should make when purchasing a new flash).

An important element is *flash power*, which relates to the total distance your flash light can travel. The *guide number* describes your flash's total power output. The higher the guide number, the more power the flash possesses. A flash's power is analogous to the horsepower of a car: The bigger the engine, the greater the horsepower and the more powerful the vehicle. A more powerful flash gives you more shooting options because it provides the requisite flash output for more situations without forcing you to adjust other exposure settings. It's my feeling that a guide number of 110 or higher will give your flash "engine" plenty of muscle.

The *flash range* refers to the closest and the farthest points a subject can be from the flash to obtain an acceptable exposure. Each flash unit has a certain range of flash ability based on the total power it can produce. As just noted, the higher the guide number, the higher the flash output. Following up on that, the higher the flash output, the greater the distance the flash can travel (the greater the flash range). On the other hand, the lower the guide number, the lower the flash output. The lower the flash output, the shorter the distance the flash can send light.

The guide number for my Nikon Speedlight SB-900 is 157, and it has a range of roughly 2 to 65 feet based on an ISO of 100. So for the SB-900, 2 feet is the closest a subject can be; anything closer will be over-flashed. And 65 feet is the farthest the subject can be (unless I increase my ISO). Beyond 65 feet, the light falloff (based on the Inverse Square Law) will be too great to properly expose the subject.

The camera settings that affect your flash range for a specific exposure are aperture and ISO. Adjusting aperture affects the range because you are widening or constricting the hole through which light travels to reach your image sensor, thus allowing more or less light to reach it. For example, changing your aperture from *f*/4 to *f*/11 shortens the flash range because *f*/11 allows in less of the flash light while the shutter is open, so it requires a greater amount of your flash's total light output because that light has to squeeze through the tiny *f*/11 opening for a proper exposure. Go the other way, from *f*/11 to *f*/4, and you extend the flash range substantially because it takes less of the flash's light to slide through the wider *f*/4 opening, allowing the light to reach much farther.

ISO impacts flash range because a higher ISO makes your image sensor more sensitive to light, so less flash output is required to properly expose an image. As a result, a higher ISO increases the flash range.

To determine your flash range for a given exposure setting, you could go through a series of calculations before every click of the shutter. Or if you're like me and don't want to crunch numbers before every flash picture, you could just use the automated distance scale on the back of your electronic flash. The flash manufacturers have already done the math for you, and all the information you need is right there.

If you determine your flash can't reach a particular subject, the easiest thing to do is change the flash-to-subject distance by moving closer and bringing your subject within range. If moving closer isn't an option—say you're photographing wildlife and you can't just walk up to the animal—you can increase your flash range by widening your aperture or increasing your ISO. Just be careful of depth-of-field concerns if you're opening up your aperture and shooting a subject that requires a bit more depth of field. Many modern DLSRs let you go up to ISO 1600 with very little noise, opening up a wealth of long-distance shooting options by combining flash and high ISO.

I CAME UPON THIS MOOSE FEEDING *in a small pond just off Going-to-the-Sun Highway in Glacier National Park. It was near dusk, so the available light was minimal at best. Plus, the moose was about 90 feet away from the road. With my camera and lens on tripod and ISO 200, I set the lens wide open at f/5.6 and adjusted my shutter speed until 1/15 sec. indicated a correct exposure. Motion blur wasn't a risk; the moose was moving through the water at a speed that would make a snail look like it was breaking the sound barrier. Unfortunately, the somewhat flat light was far from flattering. I could use my flash, giving the moose a bit of a "pop" that would also include catchlights in the eyes, but with ISO 200, my flash would never reach the moose. However, once I increased my ISO to 800 on both the camera and the flash, the flash distance scale offered up a new setting that indicated a correct flash exposure was now possible far beyond 66 feet. As this image shows, my flash exposure of f/5.6 for 1/30 sec. not only gave the moose a bit of a pop but it also provided that catchlight in the eye.*

Nikon D300S, 70–300mm lens, ISO 200, f/5.6 for 1/30 sec., Speedlight SB-900

Recycle Time and Flash Duration

Another consideration is the speed of your flash when making multiple exposures. Recycle time and flash duration are the two things to consider here. *Recycle time* refers to how long it takes for the flash to return to full power between flashes. Most flashes, on a fresh pair of batteries, will return to full power easily within several seconds. However, if you're planning to shoot in rapid succession over the course of an hour or longer, don't expect your flash to keep up with you beyond the first 15 or 20 minutes.

Think of a portable electronic flash's recycle time as a person with healthy lungs about to blow out fifty birthday candles on a cake. The person sits back in the chair, takes a really deep breath, and then blows across the cake. Sure enough, that person has extinguished all fifty candles with a single, powerful breath. But wait! No sooner are the candles blown out when another cake is brought out, and those candles have to be blown out quickly because another cake is in on the way—and then another and another and still another. You can imagine that even someone with the healthiest of lungs will soon be feeling faint and need to stop to rest a bit just to regroup to full power. And while our lungs can fully recover after a few moments of rest, the batteries in the flash expel quite a bit of power, diminishing their initial "full power" and requiring longer recycle times.

You can dramatically shorten or even eliminate a flash's recycle time by hooking it up to a separate battery pack. Using a powerful battery pack, such as those made by Quantum Instruments, would be like hooking up our candle blower to a pure-oxygen pump that constantly refreshed the blower's air supply. These battery packs can be expensive, though, and they probably only make sense if you're planning to do a lot of rapid shooting for long periods of time, as do wedding photographers, sports photojournalists, and event photographers.

For the most part, when I talk about portable electronic flash in this book, I'm referring to flashes that use four AA batteries. You'll quickly discover—and often at the wrong time—that these portable flashes love to feast on AA batteries. Some photographers buy only alkaline batteries, and lots of them, while others use AA rechargeable batteries—either nickel-cadmium (NiCd) or the higher-capacity nickel-metal hydride (NiMh)—with a backup set or two of alkaline AAs. Regardless of how you power your flash, you should always have an extra set of AA batteries in your bag. (And note: Just because the recycle time slows down significantly in between each flash, that doesn't mean the AA batteries are spent. There's still plenty of juice left in them to operate your TV remote control or other small battery-operated devices, so don't be so quick to throw the batteries in the recycle bin just because they no longer fire the flash.)

Flash duration describes the actual speed of that burst of light, the flash "bang," released by the strobe when you press the shutter release on your camera. On average, when a flash is set to full power, the duration lasts for around 1/1000 sec. That's blazingly fast, at least when compared to the blink of an eye, which is around 1/100 sec. Some of you may own a flash whose duration at full power is 1/8000 sec., while others have a flash duration of 1/2000 sec. Again, this duration is based on the flash being set to full power (1/1).

When you reduce the flash's power, you're able to work closer to a subject and still maintain a correct exposure. As we've already learned, proper flash exposure relates to flash-to-subject distance, so the logic here is that a less powerful flash burst from a closer distance will achieve the same illumination results as a more powerful flash burst from farther away. However, something else that's noteworthy also occurs when you reduce power on your flash: The flash duration shortens. A shorter flash duration opens up a whole new world of freezing-action opportunities. Why? The bang of the flash is shorter in its duration *and* the recycle time is also much faster, since the powered-down flash expended a lower amount of power. So a shorter flash duration combined with a much faster recycle time means you can fire off more frames more quickly without waiting for the flash to recycle every 2, 4, or 8 seconds. This makes a significant difference when you're trying to shoot a sequence of a fast-moving subject.

Note that the *only* way to shorten the flash duration is to decrease the power. You can assume that with every power decrease—from 1/1 (full power) to 1/2 to 1/4 to 1/8 power and so on—the flash duration gets shorter and shorter. Using an average flash duration time of 1/800 sec. (for most flashes at full power), you can assume the duration decreases by half for each halving of the power setting. So if the duration is 1/800 sec. at 1/1, then it's 1/1600 sec. at 1/2, 1/3200 sec. at 1/4 power, and so on.

CATCHING THE SPLASH *of a simple drop of water from the kitchen faucet as it falls into a glass bowl of water is a snap when you power down your flash! To set up this shot in my kitchen sink, I covered a small cardboard box with one of my bright Hawaiian shirts to make a colorful backdrop. I placed a glass bowl filled with water on top of the shirt and box and adjusted the faucet so that it produced a steady drip of water.*

Although this is a two-light setup (opposite), rest assured that I've also been successful with a single electronic flash. With both flashes powered down to 1/16 power and loaded with fresh batteries, the recycle time was remarkably fast—almost as fast as the motor drive on my camera, which I fired at 4 frames per second. Based on the distance from the flash units to the water drop, and based on the reduced-power settings on the flashes, the scales on the back of the flashes indicated a correct exposure of the subject at an aperture of f/11. With my shutter speed set to 1/250 sec., I was able to fire off three quick frames as the water drop hit the surface of the water in the bowl. The exposure of the resulting upward splash right is one of my favorites.

Nikon D300S, 105mm lens, ISO 200, f/11 for 1/250 sec., two Speedlight SB-900s

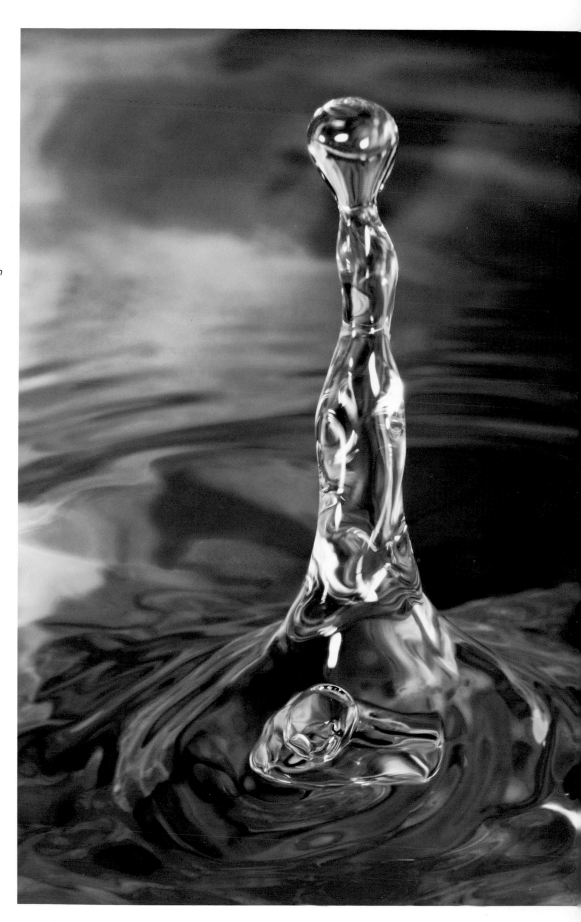

Sync Speed

Up until now, I've conveyed the idea that your choice in shutter speed should be based solely on how you wish to manipulate the ambient light. But there's another factor that will influence your choice in shutter speeds: the flash synchronization (sync) speed. The flash sync speed is the fastest shutter speed you can set on your camera while using flash without fear of losing part of your composition to darkness. (This shutter speed will vary depending on the particular situation and lighting conditions.)

To get a better understanding of this, let's review the science of flash photography. Whether you have a portable flash or several powerful studio flashes, something called the capacitor stores up energy inside the flash head. When you press the shutter release, the flash head emits the flash burst. Depending on the make and model of your flash, the rate of speed at which the flash light is expelled might be as high as 1/40000 sec. or as low as 1/800 sec.

Given these speeds, it might seem logical to then assume that the camera's shutter will be open both before and after the flash has fired. This is true, but only when you're using shutter speeds that are "in sync" with the flash. By *in sync*, what's meant is that the shutters are fully open at the same time the flash goes off.

Let's break this down a little. The shutter of every camera has two curtains. Think of your shutter opening and closing in much the same way as two stagehands opening and closing the stage curtains in a dark theater. The first curtain begins in a closed position, and the second curtain begins in an opened position. At a designated signal, the first stagehand begins to open the first curtain, moving left to right. Once that curtain has gotten to the end of the stage, fully exposing the dark stage, a spotlight from the back of the theater quickly flashes on and off, briefly illuminating everything onstage. The shutter speed in use will then determine just how quickly the second stagehand begins closing the second curtain, also moving left to right so that it covers the stage that was exposed by the opening of the first curtain.

In this analogy, the signal to open and close the curtains is the pressing of the shutter release button on your camera. The speed at which the second stagehand begins to close that second curtain is determined by the choice in shutter speed. It might be 1/60 sec. or 15 seconds or any other shutter speed that's in sync with the flash when it fires. When you use a shutter speed that's not in sync with the flash (faster than the maximum sync speed of your camera), then the second stagehand has already begun closing the second curtain before the first stagehand was able to fully open the first curtain and reveal everything on the stage. And since the second stagehand has already started closing the second curtain when the spotlight briefly turns on and off, a portion of the stage will never be illuminated. In your picture, this unilluminated area will record as black, because it never saw the flash go off. In other words, the shutter was already closing on that part of the frame when the flash burst occurred.

By now you may be understandably concerned over your ability to remember to set the correct sync speed on your camera, but this fear may be unwarranted. Many newer cameras won't let you take a photo at an incorrect sync speed when your portable electronic flash is attached to your camera. These cameras automatically reset the shutter speed dial to the maximum sync speed when the flash is in the camera's hot shoe or tethered to the hot shoe via a flash cord. (The problem of not being in sync is more likely to happen when you use the flash off camera, via remote triggers. I'll get to some techniques for working with off-camera flash via remote on page 122. For now, just remember that when using the flash off camera, you should add this one-liner to your checklist: Before I shoot the mink in the rink, make sure I'm in sync!)

For an example of this auto sync-speed resetting, assume for a moment that you're shooting your son's soccer game at the blazingly fast shutter speed of 1/2000 sec. Then the game ends, and you want to shoot a team photo. It's midday, with the sun directly overhead, so your subjects have the raccoon eyes that we discussed earlier. You reach for your flash to provide some fill light to illuminate those under-eye shadows, and as soon as you attach the flash to your camera, it may automatically reset from 1/2000 sec. to its maximum sync speed for flash. Your cutting-edge camera just saved you from making an out-of-sync exposure.

To check your camera's automatic max sync-speed settings, set the shutter speed to 1/1000 sec., attach the flash, and turn it on. See if the shutter speed resets and to what speed. If it did reset, that's your max sync speed. To return to the higher shutter speed, just turn off the flash, and the shutter speed should reset to the previous speed. Older camera models may act differently and not reset to the max sync speed when you turn on the flash. If this is the case, when you take a picture at the faster, out-of-sync speed, you'll have a black border along the long edge of your picture showing the shutter closing before the flash duration was complete.

There are an abundance of sync speeds—currently, often as fast as 1/200 sec. or 1/250 sec. Most modern DSLRs also include a high-speed sync feature that allows you to use your flash at any shutter speed and still be in sync. There's more on high-speed sync on page 112, but basically, when

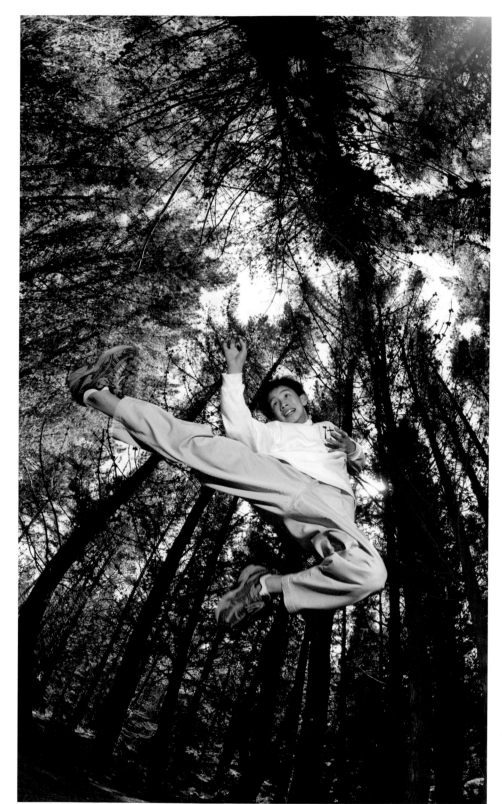

ON LOCATION IN THE NEW ZEALAND *forest outside of Christchurch, this young man named William was kind enough to make repeated leaps while, one by one, my students and I made flash exposures from a low angle. Because I wanted to combine the correct exposure for freezing action with the correct exposure for the surrounding natural light in the forest, I first set my shutter speed to 1/250 sec., the fastest normal sync speed, which is fast enough to freeze most subjects when using flash.*

Before William started his leaps, and with my shutter speed already set, I adjusted my aperture until f/16 indicated a correct exposure for the light of the surrounding forest. That aperture dictated that I also set the flash to f/16 so that the light output of the flash and the ambient light of the forest would record the same exposure. All that was left to do was note the suggested flash-to-subject distance on the distance scale—7 feet in this case— and place the flash at that distance from William. So I placed the flash 7 feet from the spot at which I expected William to be in peak form and made the exposure.

Nikon D300, Nikkor 14mm fish-eye lens, ISO 400, f/16 for 1/250 sec., Speedlight SB-900

engaged, high-speed sync lets you use flash at *any* shutter speed—yep, at 1/500 sec., 1/8000 sec., and anywhere in between. You could turn on high-speed sync, leave it on, and, lo and behold, you'd never have to worry about your sync speed again. Now, you may be thinking that you're liberated, free from the confines of having to even think about your designated sync speed, but there's a catch: When high-speed sync is on, you will lose at least half of the flash's power—even more as you increase the shutter speed. That's because, as mentioned before, the only way to shorten the flash duration is to reduce the flash power. That's a big trade-off. Since I often need all my Nikon Speedlight SB-900's output ability, I leave high-speed sync turned *off* and only use it when needed. High-speed sync is a useful feature, but in all likelihood, you'll do 95 percent of your flash work within the range of the normal sync speeds.

Exposure Compensation

Exposure compensation (EC) is used to increase or decrease your exposure beyond what the camera recommends. It has nothing to do with flash exposure. The term *bracketing* indicates that you're "compensating the exposure" by shooting at the camera's recommended normal exposure, then underexposing the next image, and overexposing a third image. When you do this, you're using EC. There's no EC button on your camera; EC is simply a name for the process of changing the exposure from what the camera suggests by intentionally underexposing or overexposing.

You can use either aperture or shutter speed to compensate your exposure, but with flash, EC often refers to a shutter-speed adjustment to compensate for the ambient-light exposure. So, when the camera's light meter recommends an exposure setting based on its interpretation of the scene, you set that exposure in Manual mode by turning the appropriate dials until the camera's exposure scale indicates a proper exposure. (Aperture Priority and Shutter Priority modes set the rest of the accurate exposure automatically once you set the "priority" setting—i.e., aperture in Aperture Priority mode and shutter speed in Shutter Priority mode.) If you want to then override these recommendations, that's when EC comes into play as you adjust (most likely) your shutter speed to change the ambient-light exposure (1 stop faster for 1-stop underexposure and 1 stop slower for 1-stop overexposure).

IF SHUTTER SPEED CONTROLS *the ambient-light exposure and aperture controls the flash exposure, which element would you adjust if you wanted to darken the background behind your subject? Shutter speed. Since your flash doesn't always reach the background behind your subject (depending on the flash-to-subject distance), the background isn't affected by any changes you make to the flash output. So if your subject is perfectly exposed by the flash but the background is brighter than you wish (above), then you can use exposure compensation and adjust the shutter speed, making it faster by 1 or 2 stops to darken the background.*

Note that if the background were too dark for your tastes, you could also do the reverse, adjusting the shutter speed to be slower by 1 or 2 stops to brighten up the background. It's your choice as to what's a "correctly exposed" background, as long as you remember to adjust only the shutter speed. This will result in changing only the ambient light in the overall exposure, thus leaving the flash exposure unchanged.

In the case of Hampton the bulldog here, I decided on a 2-stop underexposure of the ambient light after seeing my first exposure. In my opinion, a far more dramatic flash/ambient-light exposure resulted from this underexposure. If you're shooting a scene like this in either Aperture or Shutter Priority mode, you would set the autoexposure override to -2. Just don't forget to return the override back to zero when finished, otherwise all of your subsequent shots will be 2-stops underexposed, too.

Both photos: Nikon D300S, 16–35mm lens, ISO 200, Speedlight SB-900. Above: f/16 for 1/30 sec. Opposite: f/16 for 1/125 sec.

Flash as Key Light

In all lighting, the main light is called *key light*; this is typically the brightest, most dominant light on the subject. Any other light source is secondary. Imagine that you're at your daughter's choral concert, and she has a solo. As she comes from backstage, she walks into the spotlight shining on the microphone—a future singing idol brilliantly illuminated, you are certain. This bright spotlight is the key light. Any other lights, including your portable electronic flash, are supplemental light sources.

When you use your flash as the key light in a scene, you can create some very interesting photographs. When you have your digital camera set to Program (P) mode and you turn on the flash and snap a photo, the result is usually what's called a "flash-key" photo: The subject is bright from the on-camera flash, and the background is darker. In a flash-key photo, the flash is the dominant light source, and it's this "flashed" look that we commonly associate with on-camera flash photography. Fortunately, you can

WHEN SOME CLOUDS PARTED *on this scene above Kalispell Lake in Montana, I quickly opted to record a flash shot of the one lone tree on the shoulder of the road. Why flash? I didn't like the silhouetted look I was getting with just an ambient-light exposure (above). I wanted to kick up the contrast between the sky and the tree, and the best way to do that was to illuminate the tree with my flash.*

With my camera and lens on tripod, and with my aperture set to f/22, the available-light exposure for the beautiful sky was 1/2 sec. So with my flash now set for f/22, the flash distance scale indicated a flash-to-subject distance of 4.4 feet. Since I was only about 4 feet away, I was good to go. As you can see at right, the tree was illuminated against that beautiful sky.

Right: Nikon D300S, 12–24mm lens, f/22 for 1/2 sec., Speedlight SB-900

use flash key to create very interesting effects with exposure compensation through shutter speed to lighten or darken the background.

The method is simple and involves flashing the subject by manipulating the ambient exposure—making the part of the subject you light appear brighter than the ambient light on the scene. To achieve a flash-key lighting look, meter the scene and adjust your shutter speed to a minus (–) exposure compensation (EC) setting from the meter's recommended shutter speed. This will darken the background ambient-light exposure. For example, if your metered settings are *f*/11 for 1/60 sec., change the shutter speed 1 stop (-1 EC) to 1/125 sec., and the background will be darker without affecting the flash exposure on the subject. This shutter-speed adjustment makes the flash appear brighter than the ambient light on the scene, and this added contrast between light and dark emphasizes the flash as the key light.

LET'S TAKE A LOOK AT A REALLY SIMPLE EXAMPLE *that's perhaps familiar to us all. You find yourself out on a family picnic at the beach and your teenage daughter's boyfriend has tagged along. (Hey, it's far better than letting her stay home alone with the guy!) Everyone has a great time, and the day is about to come to a close as you see the sun getting low to the horizon. Your daughter comes rushing over to ask you to take a picture of her and Chaz against the sunset that she can put on her Facebook page. As you frame them against the background palm trees and setting sun, you choose an aperture of f/22 to render sharpness from front to back. As you adjust your shutter speed, the light meter indicates 1/160 sec. for a correct exposure, based on ISO 100. But your daughter is not happy with the results, which have turned her and Chaz into silhouettes. She wants a shot that shows all the world that she is with Chaz!*

So, since you know that 1/160 sec. is one of the many sync speeds, using your flash to "fill" in their silhouettes is a clear option. If you positioned them off center to the left (as I've done here), you'll also need to place the flash off center to the left. And you have several options: You could fire the flash with the aid of a flash cord running from the flash to the camera's hot shoe. Or you could use a remote radio, such as those made by PocketWizard, and have someone hold the flash in position for you. Or if you own a Canon 7-D camera and Canon 580 flash or a Nikon and the Nikon Speedlight SB-900, you could fire the flash wirelessly, since the flash will be within close range of you.

At this close range, the flash will indicate that at a flash-to-subject distance of about 5 feet, you need an aperture of f/22, which matches what you needed for the natural-light exposure, so it's all systems go. Press the shutter release, and it's bingo bango bongo time; sure enough, your subjects are illuminated, the shot is up on Facebook, and you are your daughter's hero!

Nikon D300S, 24–85mm lens at 35mm, f/22 for 1/160 sec., Speedlight SB-900

Flash as Fill Light

On page 14 I mentioned the range of light, from shadows to highlights, that our eyes can see (around 16 stops) versus what the camera records (around 7 stops). This difference between shadows and highlights is referred to as *dynamic range*. The dynamic range is quite broad (or high) on a bright, clear day and more limited (or low) on a foggy morning. Your camera will have trouble properly exposing all the highlights and shadows on a bright day that has high dynamic range (a lot of contrast), while it can more accurately "see" and expose the full range on a cloudy day that has low dynamic range (less contrast between highlight and shadow).

When you photograph a scene with great contrast (high dynamic range), the image often works better when the exposure is closer to what works best for the highlights over what works best for the shadows. This results in perfect highlights at the expense of the shadows, which is more visually pleasing than good shadow detail and blown-out highlights.

So how do you get both well-exposed highlights *and* well-exposed shadows? Use flash to fill in those dark

shadows and lower the dynamic range by exposing the shadow detail. Flash used in this way is called *fill flash* or *fill light*, and it's one of the most common uses of flash. (You can also create fill light without flash by using a reflector to bounce light into shadow areas.)

Using the example of your daughter's concert from page 66, again, there you are, ready with your camera and flash, sitting in the audience waiting for her to walk up to the microphone for her solo. The spotlight that lights your child so brightly from above (the key light) is, like the sun on a bright day, quite high in contrast. It can produce some

dark shadows on her face and possibly even the raccoon-eyes effect I mentioned earlier. Thankfully, you have your portable electronic flash so you can *fill in* the light and reduce the contrast from this strong overhead light.

Fill flash has many other uses, as well. For example, backlit subjects can benefit from fill flash when you aim flash into the shadow side of the subject (the shadow side is the front side with backlit subjects). And wildlife photographers are known to use fill flash simply to add a "catchlight" (an eye highlight) for that little bit of sparkle in an animal's eyes.

TRYING TO GET A GOOD PORTRAIT OF ANYONE—*whether it's the wife, kids, or complete strangers—in harsh midday light isn't so much a challenge as much as a foregone conclusion: It just doesn't work. Time for fill flash!*

Without the benefit of any flash (above), this exposure of a young girl at a camel festival in the United Arab Emirates has all of the telltale signs of midday light: high contrast between light and dark areas—and the squinty eyes in heavy shadow. If you think of ambient light as the key light (or main light), while any fill flash is secondary light, this first exposure was set for the key light. And it's a technically correct but far from flattering exposure of this little girl. When I added flash (left), I "filled in" the shadow areas and created a far more flattering image.

Note that, as is often the case when shooting basic fill flash, I didn't shoot the flash exposure at the recommended setting but rather at a 1-stop underexposed. In this scenario, the available-light exposure was f/16 for 1/200 sec. without flash, and I wanted just enough flash to fill the shadow areas. So rather than set the flash to f/16 at the indicated flash-to-subject distance, I set it to f/11 while keeping my camera exposure setting at f/16. This essentially tricked the flash into thinking that it needed to put out less light for the more open aperture of f/11. The flash power was, in effect, reduced by 1 stop. By keeping my lens set at the smaller aperture of f/16, I prevented my flash from overpowering the natural light present in the scene and washing out the subject. This filled in the shadows nicely and lowered the dynamic range (the contrast between light and dark areas), giving the image a more natural and less "flashed" appearance. The key point here is to adjust the flash's output—not the camera's exposure setting—when trying to achieve a more evenly lit exposure with fill flash.

Both photos: f/16 for 1/200 sec. Left: with Speedlight SB-900

WATCH OUT FOR THOSE SUBJECTS IN HATS! *The human eye is an amazing machine in its ability to see light and dark simultaneously. Your camera doesn't see the full dynamic range as well, so scenes in which the subject is in partial shadow (under the brim of a hat) may need a little extra illumination.*

When I set my aperture to f/8 and adjusted my shutter speed until 1/160 sec. indicated a correct exposure in the camera's meter, it was immediately apparent that the subject's hat was causing an underexposure on his face. Since I wanted to keep the hat in place, fill flash came to the rescue. Staying with the available-light exposure I'd just made, I dialed in f/5.6 on the back of my flash—again, lowering the flash power so as not to over-flash the subject. Based on this setting, the distance scale on my flash told me I needed to be at 27 feet at full power, 19 feet at 1/2 power, and 13 feet at 1/4 power. Since I was about 12 feet from the subject, I used the 1/4 power setting. And since I was actually using an aperture of f/8 on my lens, this flash-to-subject distance resulted in a 1-stop underexposure—just enough to fill in his face with some illumination without overpowering the scene with flash light.

Both photos: Nikon D300S, 24–85mm lens at 32mm, f/8 for 1/160 sec. Left: with Speedlight SB-900

MANY TIMES, FILL FLASH *is something that readily comes to mind when the main subject is in harsh midday light. But fill flash can also be used to shed some light on dark backgrounds. Here, my subject, Cliff, was sitting in open shade beneath an overhanging roof. The many items on display for sale behind him were also in open shade, but since they were farther back on the porch, they were in even darker shade than Cliff. At f/8 for 1/90 sec. with no flash, a pleasant exposure of Cliff resulted, but not surprisingly, the background behind him recorded quite dark, since 1/90 sec. wasn't enough to correctly expose that part of the composition opposite.*

Directing some fill flash into the background area above, lit up the background with just enough light to match the available-light

exposure of Cliff's face (above). It's a simple fill-flash exposure, really: I dialed f/8 into my flash, and the distance scale indicated that the flash needed to be about 9 feet from the subject. I also added a light-amber gel to the flash to create a warmer light in the background. My son stood to the right of Cliff, holding the remote flash up high at a distance of about 9 feet while pointing it downward at a 45-degree angle, and I fired away at f/8 for 1/90 sec. What was once hidden was revealed by the "sunlight" from my flash.

Both photos: Nikon D300S, 24–85mm lens at 45mm, f/8 for 1/90 sec. Above: with Speedlight SB-900

IN THIS EXAMPLE, MADE DURING A WORKSHOP *in Singapore, I at first set my aperture to f/11 and adjusted my shutter speed to 1/60 sec., and shot using only the natural light. Note the darker background in the resulting portrait. The overcast ambient light was sufficient for the subject but not for the backdrop of this motorcycle-parts business, which gets lost in the darkness due to light falloff.*

For the second attempt, I had one of my students hold up a flash to spread light behind my subject (opposite, bottom). I was then able not only to render the pleasing natural-light portrait of my subject but also to achieve some degree of illumination behind him, revealing his shop and even his father reading a paper in the lower right corner of the scene.

Combining the ambient exposure with the flash exposure is, again, an easy proposition. With my lens at f/11 and my shutter speed set for the ambient light falling on the main subject, I simply set the flash to f/11 and had my student/assistant hold the flash about 6 feet from the background. The flash indicated I should power it down to 1/4 power, and as you can see, that was correct.

Both photos: 24–70mm lens at 35mm, ISO 200, f/11 for 1/60 sec. Above: with Speedlight SB-900

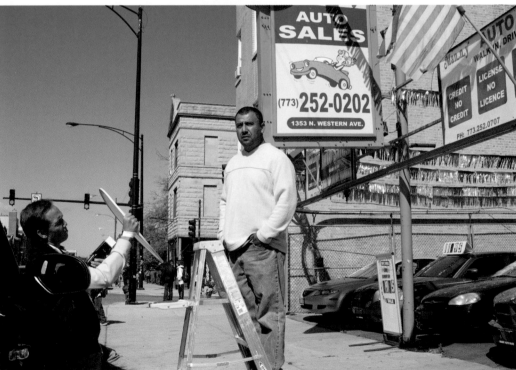

LOCATED ALONG CHICAGO'S ECLECTIC WESTERN AVENUE, Manny's Used Cars is one of the many mom-and-pop businesses on the street that demonstrate Chicago's diverse culture. Manny said "No thanks" to my photo request but was quick to offer up Jorge, one of his salesmen. Working in direct midday sunlight, I wanted to elevate Jorge and shoot from down low as he looked up, so I placed him on a ladder. As you can see in the top image on the facing page, the light on Jorge's face was harsh. So I had my assistant, Jim, hold my Nikon Speedlight SB-900 and a diffuser panel (opposite, bottom). Firing the flash through this diffuser made the normally unflattering light of a bare, direct flash softer and more flattering. It also spread out the light so that it wasn't such a direct beam on Jorge's face. As you can see below, the fill flash did a nice job of cleaning up the harsh light and filling in the shadows with good light.

Note that normally I'd adjust the flash power to 1/2 power in this type of situation yet remain at the flash-to-subject distance indicated for 1/1 power to avoid washing out my subject with too-powerful flash light. However, since the diffuser will easily eat up about 1 stop of the light passing through it, this wasn't necessary. With both the camera and flash in Manual mode, I chose f/22 for the depth of field I wanted, and the camera's light meter responded with 1/100 sec. as a correct exposure for the available light. At f/22, the distance scale on the back of the flash told me the flash needed to be 8 feet from the subject. I then had Jim position the flash to fire through the diffuser from this 8-foot distance, and not surprisingly, the flash illuminated Jorge just enough (a 1-stop underexposure) to "fill in" the deep shadows that were once across his face.

Both photos: Nikon D300, 17–35mm lens at 35mm, ISO 200, f/22 for 1/100 sec. Below: with Speedlight SB-900 and diffuser

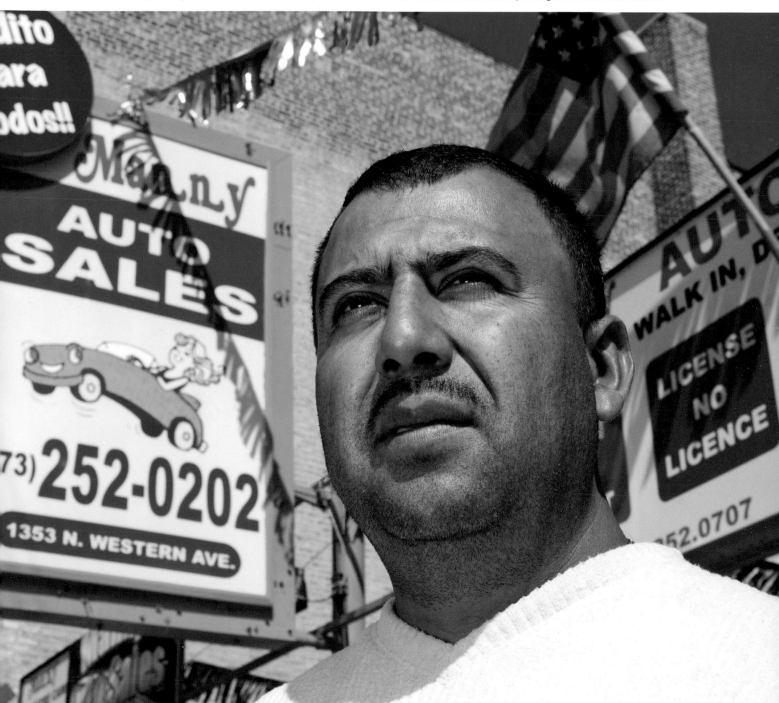

Isolating with Flash

One of the most common compositional choices is to isolate a subject from an otherwise busy scene. *Isolation* or *singular-theme compositions* owe their impact in large part to simply having one subject as the center of attention—if done well, there really is nothing else to detract from the subject and distract the eye/brain as it views the resulting image.

Effective isolation relies in large part on the photographer's ability to combine both proper lens choice and proper aperture (most often a telephoto lens and a large lens opening, such as *f/4* or *f/5.6*) with a background that can be rendered into out-of-focus tones or shapes. Sometimes, if not making use of a background like this, a photographer can search out a subject that is frontlit or sidelit and choose a point of view that showcases the sunlit subjects against a background of open shade; since the exposure in these cases is made for the much brighter foreground subject, the area of open shade behind the subject records as a very dark (if not black) underexposure. It is this extreme contrast between light and dark that can also be used to isolate a subject from an otherwise busy and chaotic scene. And you can also create this lighting contrast using your flash.

THE SUNNY 16 RULE

When mixing flash and ambient light, it's helpful to understand proper daylight exposure. For manual shooters, the Sunny 16 Rule provides a great starting place for ambient-light exposure on a bright sunny day. Sunny 16 states that when shooting in natural light on a sunny day, beginning about 1 hour after sunrise and lasting up to 1 hour before sunset, all frontlit and sidelit scenes will record a correct exposure at *f/16* with a shutter speed denominator that matches your ISO. So for example, if you point your camera toward the blue sky to the west at 10:00 AM using *f/16* and ISO 200, your meter should give you a shutter speed of 1/200 sec. for a correct exposure. If you're using ISO 100, then your shutter speed should be 1/100 sec. If nothing else, the Sunny 16 Rule is a great way to check if your in-camera meter is working correctly.

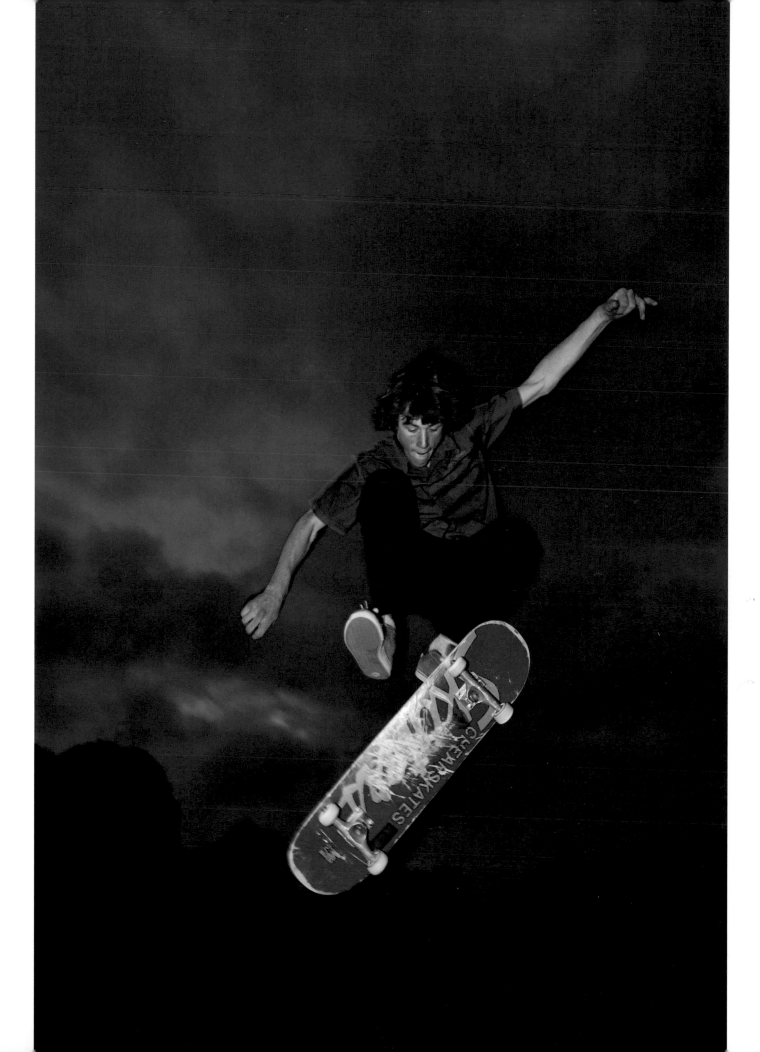

FOR YEARS I'D SEEN *my share of photographs of Peggy's Cove and its famed lighthouse in Nova Scotia. But it wasn't until the fall of 2010 that I experienced Peggy's Cove firsthand—and I wasn't the least bit disappointed!*

One evening following sunset at the lighthouse, my attention turned to the east, where there remained some wonderful cyan and magenta colors in the sky. The lighthouse was still fairly illuminated by the much brighter sky to the west, but the rocky landscape surrounding it had turned dark (left). But even though the sun had set, that certainly didn't mean I couldn't re-create that sunset and its low-angled light.

For that first exposure, with my camera and lens on tripod, I chose an aperture of f/22 for maximum front-to-back depth of field. I took my meter reading while pointing my camera to the eastern sky above the lighthouse and adjusted my shutter speed until the camera's light meter indicated 2 seconds as the correct exposure.

I then pulled out my flash, dialed in the aperture of f/22, and found that at full power I could illuminate the rocks with a flash-to-subject distance of 7 feet. Holding the flash out to the left at about the nine-o'clock position, and with the camera in Commander remote firing mode, I fired the shutter at the same exposure as I had previously used—and voilà, the flash lit up the foreground rocks in much the same way as the sun had done only 10 minutes earlier. And the sidelighting created by the nine-o'clock flash position also emphasized the rocks' texture.

Both photos: 16–35mm lens, f/22 for 2 seconds. Opposite: with Speedlight SB-900

THERE I WAS, IN AN INDUSTRIAL AREA *near downtown Portland, and the rain clouds had finally cleared out right at sunset, leaving a wonderful dusky blue sky behind. There wasn't much to shoot in this location, other than a cyclone fence, until a nice autumn-colored leaf flew by on the wind and I got the idea to place it on the fence in front of me. With my camera in Manual exposure mode, I set the aperture to f/22 (because I wanted a lot of depth of field) and adjusted my shutter speed until my camera's meter indicated a correct exposure at 2 seconds. Although this was the correct exposure for the dusky blue sky, it was not the correct exposure for the gray fence and vibrantly colored leaf, which became silhouettes at that exposure (above).*

I could have come back in the morning and shot this scene again with the sun behind me, rising in the east and subsequently lighting up the fence and leaf—or I could re-create that early morning sunlight by using flash. The flash distance scale indicated that at f/22 the flash would light up subjects 3 feet away. So, working at that distance, I took the next picture with the flash turned on. What a difference! You may also notice here some minor light falloff in the corners of the frame, especially in the upper right; this is our good friend the Inverse Square Law at work, and at least in this case, this light falloff works in my favor, as it creates a kind of vignette effect.

Both photos: Nikon D300, 12–24mm lens at 12mm, ISO 200, f/22 for 2 seconds. Right: with Speedlight SB-900

ATOP THE VALENSOLE PLAIN near the town of Valensole in Provence, France, I set up my camera and tripod right in front of some lavender flowers. Following several hours of thunderstorms, the clouds were parting just as the sun was beginning to set. With my wide-angle lens in place and an aperture of f/22, I first made an exposure for the sunset sky that resulted in a nice exposure of the sky but a silhouetted exposure of the flowers. Since the sky was much brighter than the flowers below, this was no surprise. I then dialed f/22 into my flash, and the distance scale indicted a flash-to-subject distance of 4.4 feet. All that was left to do was raise the flash about 4 feet from the flowers at a 45-degree angle rather than straight on, and this angled position makes for a more pleasing and natural look from the strobe's light. As you can see, I was able to record a correct exposure of both the sunset sky and the foreground lavender flowers lit by the flash.

Note, too, the slight light falloff in the horizontal version below left. Despite zooming my flash to the widest-angle coverage (17mm), it was just not enough to cover the entire foreground frame of flowers, since the lens I was using had an angle of view of 12mm. However, since the angle of view in the vertical version is within range of the 17mm angle of flash output, there is no falloff recorded there and for this most obvious reason, I prefer the vertical version.

All photos: Nikon D300S, 12–24mm lens at 12mm, ISO 200, f/22 for 1/250 sec. Bottom, left and opposite: with Speedlight SB-900

Bounce Flash

What is bounce flash? It's rather simple, actually. Bounce flash refers to flash that, rather than being aimed dead at the subject, is pointed toward a nearby wall or angled up at the ceiling. The light from the flash then "bounces" off the wall or ceiling and hits your subject indirectly. You can also bounce flash light off reflectors or an attachment that sits above the flash. After flash light bounces off a wall, ceiling, reflector, or attachment, it fans out into a much softer and more even light. So perfect bounce flash will always produce a more flattering light on your subject.

Think about it this way: Try to visualize what it looks like when you're outside at midday and the harsh sun shines down on your friend. Now imagine an overcast day and the soft quality of light a cloudy sky creates as the clouds disperse the light traveling through them. Soft shadows with low contrast make for nice pictures. Flash works the same way: When pointed directly at your subject, it's often harsh and unappealing, but bounced, it becomes dispersed, soft, lower in contrast, and more flattering.

Getting that perfect bounce flash can test your patience. Do not attempt bouncing the flash for the first time on the day of your child's birthday party. Instead, several days before the party, start practicing the technique. As an experiment, place a teddy bear, other doll, or any "model" in a chair. Now frame up the shot just the way you'd hope to frame it during the upcoming party. With your camera in Manual mode, establish your correct flash exposure based on the distance between the flash and teddy bear, and then set the corresponding aperture on your lens. Next, aim, focus, and photograph the teddy bear. Let's assume that your flash-to-subject distance dictated f/16. With the lens set to f/16 and your shutter speed set to 1/60 sec., you'll no doubt be quick to notice that the image on your digital monitor is very familiar—it's that deer-in-headlights look (or, in this case, a bear-in-headlights look) discussed earlier. The teddy bear is stark, is full of contrast, and has left its mark: a shadow on the wall behind the chair.

Obviously, you no longer want to point the flash directly at any of your subjects, at least when shooting indoors. You don't want those dark backgrounds or looming dark shadows on the wall behind your subjects. You want an even exposure throughout the entire composition, if possible. With well-executed bounce flash, you not only light your subject, but you can light the room around your subject, as well—without any of those hard shadows you'd otherwise see. However—and this is vitally important when you use bounce flash—based as usual on the flash-to-subject distance, you must open the aperture up about 2 stops prior to shooting your subject.

Back to the teddy bear in its chair: An aperture of f/16 was indicated, but now you're going to bounce the flash, so you open the aperture up 2 stops, from f/16 to f/8. This is necessary because the flash is first traveling upward and then spreading across the wall or ceiling of the room. By the time the flash's light hits this surface and bounces back down from above, our good friend the Inverse Sqaure Law has eaten up about 2 stops of light. But by setting the lens to that larger aperture (f/8, in this example), you can still record enough light for a pleasing, soft exposure.

Note that the height of your ceilings—whether 7, 8, 9, or even 12 feet—will of course impact the aperture choice, too. You may discover, depending on your location, that opening the lens 2 stops was too much, or maybe even not enough. A successful bounce flash exposure often requires some subtle tweaking, some fine-tuning, so don't be surprised if you're working with a 1/3- or 2/3-stop difference on either side of the recommended 2-stop increase in your aperture.

And just how do you position the flash to bounce it? Push in on both sides of your portable electronic flash, right where it makes that 90-degree bend, and pull your flash head back so that it points straight up. Unless your ceiling is extremely high (more than 10 or 15 feet), the light will shoot up, bounce off the ceiling, and then shower down in a more spread-out, even manner.

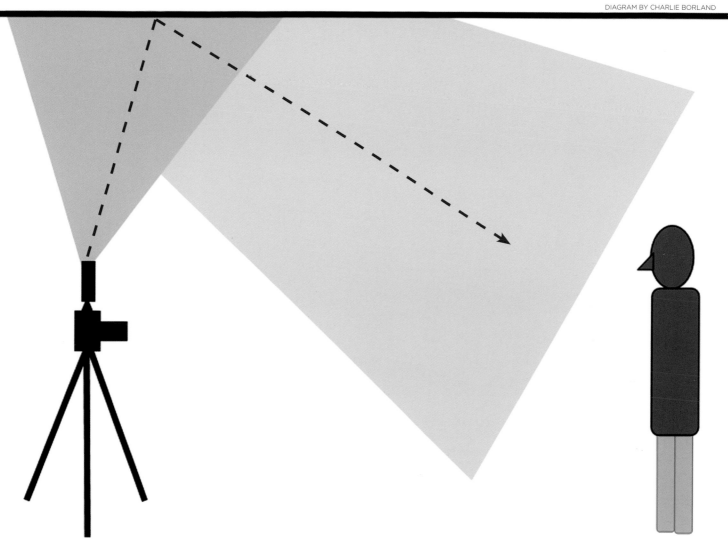

BOUNCING THE FLASH LIGHT off the ceiling (or a wall) spreads it out and creates softer, more even lighting. Bounced flash imitates the softer light produced by an overcast sky, because it spreads out after hitting a surface, dispersing in a wider, less-concentrated manner than when it left the flash—much like clouds disperse the sun's rays. This larger "light spread" results in less contrast.

AN EFFECTIVE FLASH BOUNCE HELPED ME *turn my daughter Sophie from a deer in headlights (above) back into a young lady (right). With my portable flash mounted on the camera's hot shoe and pointed straight up toward the ceiling, the light cascaded down from above, akin to having a cloudy sky overhead. With the flash directly pointed at Sophie, I got washed-out skin tones, high-contrast light, a dark background, and harsh black shadows (for example, under her chin). Bouncing my flash off the ceiling produced a more even exposure, softer light, and better-illuminated backgrounds with no black shadows.*

Both photos: Nikon D300S, 20–35mm lens at 35mm. Above: ISO 200, f/11 for 1/80 sec. Right: ISO 400, f/5.6 for 1/80 sec.

WALL COLOR & BOUNCE FLASH

Any time you bounce a flash off a nearby wall or ceiling, you must be aware of the color of those surfaces. Why? The light output of your electronic flash is incredibly "sociable" and loves to "pick up" colors from the walls or ceiling as it journeys around the room. If these surfaces are painted, say, orange, pink, yellow, or light blue, you run the risk of contaminating your subject with that same color. White and off-white generally work fine, with no influencing color, but if you're bouncing your flash off the pink walls in your daughter's ballerina-themed room, you'll record a pink cast on her clothes and skin.

On the other hand, if a room has dark walls—maybe deep red, purple, chocolate, or black—the incredibly social flash will be the one getting "picked up" along the way. Just like a sponge, really dark rooms soak up the light of the flash. With what little light is left, the subject appears underexposed. When bouncing flash in a room full of dark paint, you'll want to open the aperture up at least 1 stop, maybe 2 stops, to compensate for the absorption of light.

THE "HIDDEN" DIFFUSER & CATCHLIGHT PANEL

Your flash just might have a diffuser hidden from view in a slot at the top of the flash head. Once you discover it, you'll find that it serves two purposes as it covers the strobe head: (1) It spreads out (or disperses) the light at the widest possible angle, and (2) it also softens the light.

Pulling out this diffuser on certain flash units will also reveal a white panel known as a catchlight panel. To use just the catchlight panel, hold it with one hand while pushing the diffuser back into the same slot. The purpose of this panel is to stop the light that would normally spill out of the flash behind you and redirect it forward so that more light is illuminating the area in front of you. Since the card is so small, it's important to understand just how effective it is. Primarily, it's designed for bouncing a subtle amount of light at your subject and creating a catchlight in the eyes—producing that sparkle that every portrait photographer strives for. It won't replace a large white reflector, which is often used in the studio to spread light farther and wider, but it works well in smaller productions.

Many flash units have a hidden diffuser card (left) in a slot at the top of the flash unit.

If your flash unit doesn't have a catchlight panel, or if you want a bigger diffuser, you can easily cut a piece of white cardboard and attached it to your flash with the aid of a rubber band (below). This simple and cheap solution works as effectively as some large commercial diffusers.

DURING A WORKSHOP IN AUSTIN, TEXAS, *several students and I decided to eat lunch at Coyote Ugly on Sixth Street. One student wanted to photograph one of the bartenders but was worried about using his flash in such a dark place with such high ceilings. I told him about the little white card in his flash head. As you can see above, with that card extended, we placed the flash on a small light stand level with the counter so that the flash wouldn't be visible in the mirror behind the bartender. Also, pulling out the white card directed most of the flash power up toward the 16-foot ceiling, with some light heading forward toward the subject. Although the flash–to–subject distance dictated an aperture of f/11, I chose f/5.6, because the flash was being bounced into the ceiling, causing about a 2-stop loss of light output in this case. The result opposite was a flattering, well-lit portrait.*

Nikon D300S, 24–85mm lens at 70mm, ISO 200, f/5.6 for 1/60 sec., Speedlight SB-900

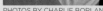

PHOTOS BY CHARLIE BORLAND

IN THE FALL OF 2010, I CONDUCTED A SMALL WORKSHOP *in the town of Siem Reap, Cambodia, most noted for its proximity to the famous ruins of Angkor Wat. Within a short walking distance of the temples of Angkor Wat is a dormitory for Buddhist monks, and not surprisingly, you will also find the orange-clad monks mingling among the crowds of tourists who visit Angkor Wat daily.*

One of the area's locations that I picked for photography included a large but dark foreground of stone walls and doorways. For this shot, beyond the dark foreground doorway and at some distance from it, two monks stood in position among several stone sculptures and in front of several large windows, where the light was much brighter, as you can see in the image above, made only with available light.

Although one could certainly argue that this dark foreground helps call attention to the brighter monks due to the extreme contrast, as one who believes that texture helps the viewer get a better feel for a subject, I felt this was the time to light up the texture in the foreground. As you can see in the second example, light it up is what I did! With the same exposure setting, I simply mounted the flash to my camera's hot shoe and pointed it straight up—with my white bounce card pulled out of the flash head. With the flash set to full power, I fired the camera, and sure enough, the flash illuminated the dark foreground, revealing the various textures therein. Given the choice between the two, I prefer that second shot.

Both photos: Nikon D300S, 16–35mm lens, ISO 200, f/22 for 1/125 sec. Left: with Speedlight SB-900 with bounce card

Shaping the Light with Off-Camera Flash

Another reason to get the flash off camera has to do with light "shape." The farther the flash is from the lens, the more shape there is to the lighting. What do I mean by *light shape*? On-camera flash is very flat, consisting of mostly highlights with few shadows. A well-lit subject has a perfect balance of highlights and shadows, giving the subject a three-dimensional appearance.

A flash placed off axis to the lens provides light with more shape and dimension, because it creates a highlight side and a shadow side to the subject's form. As the flash gets farther to the side of the camera, it creates more shadows as the angle between the light and subject increases. Using a flash in this manner is a technique favored by wedding and press photographers for creating more dimensional documentary portraits.

To that end, adding a flash bracket to a flash system makes sense for many photographers, especially when shooting weddings, parties, or groups of people. A flash bracket attaches to the bottom of your camera, and then your flash attaches to the side of the bracket, which connects to the camera with a cord. There are numerous manufacturers of brackets. The most notable is Tiffen, which makes a wide variety of flash brackets and accessories, including the well-known Stroboframe.

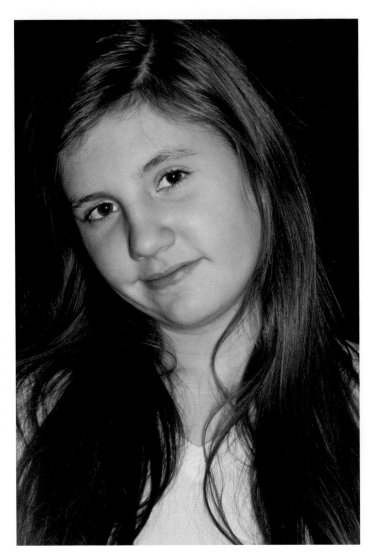

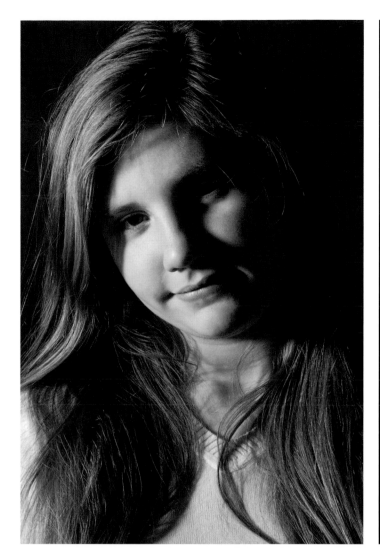

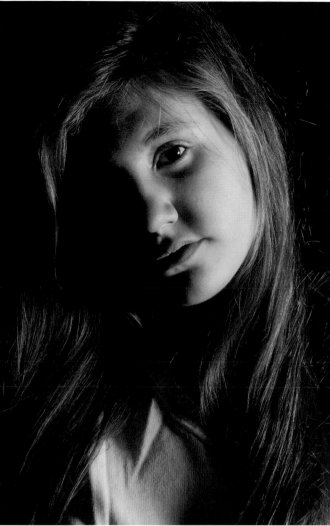

ALTHOUGH I'VE REFERRED TO THIS POINT MANY TIMES *already throughout this book, I wanted to have a section dedicated to one of the most important aspects of successful flash exposures: off-camera flash. This one aspect has everything to do with the light and its direction, and if one thing is clear in these three examples of my daughter Sophie, it's this: Shooting any flash exposure with the flash pointed directly at the subject (even when the flash is housed in a small softbox, as it is here) will more often than not result in a stark deer-in-headlights portrait (opposite).*

Note the radical shift in the mood in the next two photographs, with the flash positioned just off to my left at about a 75-degree angle to her face (above, left) and just off to my right at about a 75-degree angle to her face (above, right). The strong sidelight positioning of the flash produces images of great contrast, with a range from bright highlights to very dark shadows. Both sidelit exposures showcase the form and soft textures in Sophie's face and hair, which is in marked contrast to the flat light of the first image, for which the flash was pointed directly at Sophie.

All photos: Nikon D300S, 24–85mm lens at 85mm, ISO 200, f/11 for 1/160 sec.

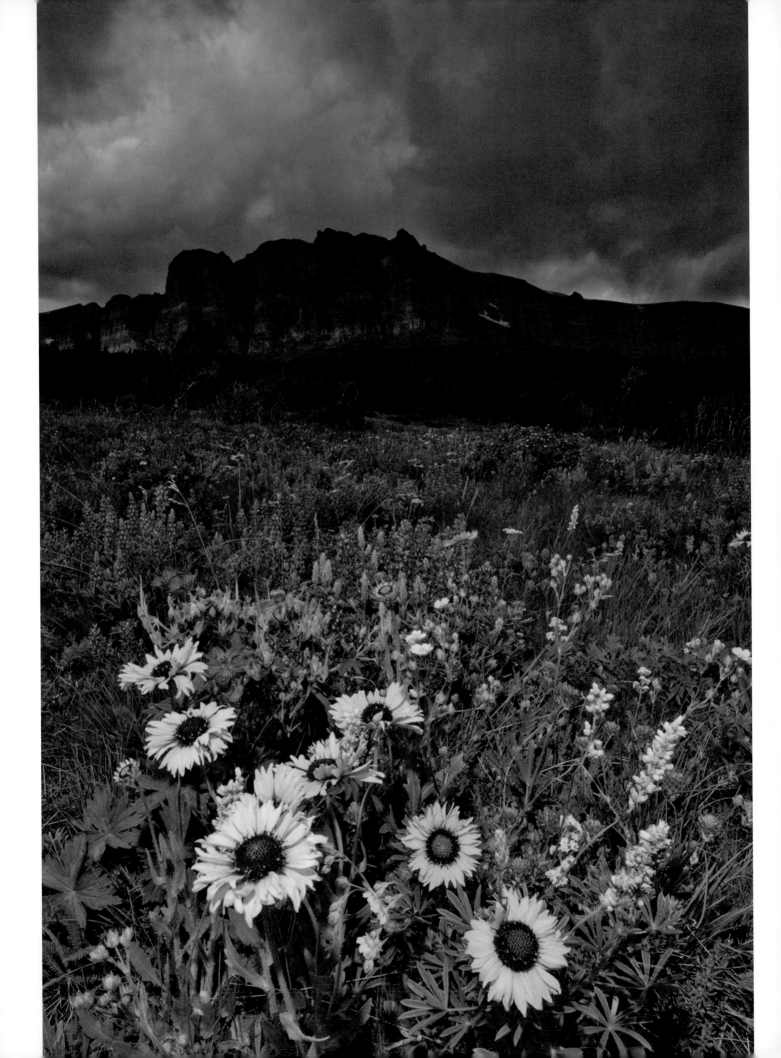

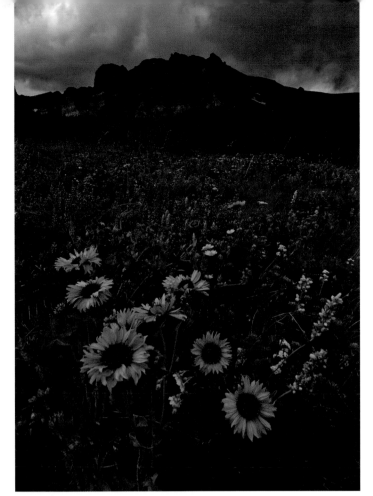

IT WASN'T JUST THE "WILDFLOWER EXPLOSION" *that brought me to a halt as I toured South Glacier National Park but also the impending storm. This was a great opportunity to use the storytelling aperture of f/22—and when combined with the flash illuminating the foreground (shaping and directing it from a low left-hand angle) and a deliberate underexposure of the ambient light, a potentially dramatic landscape was in the making.*

Since I wanted to record a somewhat narrow flash beam, I zoomed the flash head toward the narrower angle of view of 135mm. This much narrower angle of flash output (versus setting the zoom to the 28mm setting, for example), would ensure that I recorded a beam of light as it crossed over the flowers (rather than capturing the much larger swath of light expected from a wide-angle setting of the flash zoom head).

Even with the aperture dial on the back of the flash set to f/22, I noticed my flash-to-subject distance was still a whopping 10 feet at full power. No worries, since I quickly discovered that by powering down to 1/8 power, my flash-to-subject distance could be 3 1/2 feet. With my tripod set low to the ground and with my lens set to f/22, I preset the focus on my lens to one meter (this would ensure my recording sharpness from 18 inches to infinity). I then adjusted my shutter speed until my camera's light meter indicated a correct exposure with 1/30 sec. But since I wanted to add further drama to the overall scene, with its impending storm, I chose to deliberately set an exposure that would be 2 stops underexposed. This meant I'd be using a shutter speed of 1/125 sec.

Without benefit of any flash, you can see that this 2-stop underexposure is hardly compelling (above). But with my flash held out and away from the flowers in my left hand at about the nine-o'clock position and a distance of about 4 feet, the difference is clear (opposite). This image serves as a reminder that correct flash exposure is about the right aperture that corresponds to the chosen flash-to-subject distance and that shutter speed's role in flash photography is still limited to controlling only exposure of the ambient light.

Opposite: Nikon D300S, 12–24mm lens at 15mm, f/22 for 1/125 sec., Speedlight SB-900

OFF-CAMERA FLASH POSITIONS

There are various options for handholding a flash off camera. The top image (A) shows direct flash, meaning the off-camera flash is aimed directly at the subject. The center image (B) shows bounce flash aimed at the ceiling. An off-camera bounce flash position produces different highlights and shadows than on-camera bounce flash, and it helps avoid the deer-in-headlights look of on-camera flash. The bottom image (C) demonstrates bounce flash aimed at the ceiling in combination with the use of a diffuser panel. Using a diffuser panel when holding your flash off camera produces a better quality of light, because the bounced light fills the room while also providing an angled directional light source on your subject.

PHOTOS BY CHARLIE BORLAND

Rear-Curtain Sync

As I mentioned on page 62, cameras come with focal-plane shutters that contain two curtains. The first curtain opens when you press the shutter release, and the second curtain closes the shutter once the exposure has been recorded. Normally, the flash fires immediately after the first curtain has fully opened. Now imagine for a moment that when the first curtain fully opens the flash doesn't fire. Instead, it waits to fire until the second curtain begins to close. In other words, rather than the flash firing at the beginning of the exposure, it fires at the end. Why, you ask, would you care about this? One reason and one reason only: You wish to make a longer-than-normal exposure in which motion is present.

Combining motion with flash is still, for many, uncharted territory. When you wish to combine motion and flash, particularly in low light, you'll want to make use of *second-curtain* or *rear-curtain sync* mode. Simply put, this mode allows time for a low-light ambient exposure to record first, and once that part of the exposure is finished, the second curtain sends a signal to the flash that it's about to close. At that point, the flash finally fires.

So what difference does it make if the flash fires at the beginning of the low-light exposure or at the end? After all, flash is flash, right? Yes, flash is flash, but keep in mind that we have, in effect, two exposures going on here. The first is the exposure that we calculated for the natural light, and the second is the flash exposure.

Imagine that you're shooting your son riding his bike. He's wearing his helmet, and you've attached one of those headlamps to it that not only lights up a bit of the sidewalk in front of him but also makes him easy to see. You grab your camera and are going to try this really cool idea of panning him as he goes by. Let's say you're photographing him from 12 feet away, and you find that you need an aperture of f/16, ISO 200, and a shutter speed of 1/15 sec. for a correct exposure of the natural light. Okay, you're all set and tell your son to start riding. You pan along with his motion, and as he passes in front of you at 12 feet away, you fire the shutter release. You've captured a really nice panning shot of your son, or have you? When you check the image on your LCD screen, you see a long light streak running into his head. Why is the light from the headlamp streaking across his head? Because you're shooting with your flash in *first-curtain sync* instead of *second- (or rear-) curtain sync*, which would be more practical in this situation.

Had you shot this image in rear-curtain sync, that streaking light atop your son's helmet would have been allowed to "streak" across the frame during the entire length of the exposure before being lit by the flash. Instead of seeing your son running into the streaking headlamp, the streaking headlamp would *follow* him, since the flash exposure

in rear-curtain sync is made at the end of the exposure. Using first-curtain sync where any motion is involved is a bad idea, since it allows for all that motion to overlap and interfere with your flash exposure. If all of that motion stuff is allowed to do its thing first, then the flash exposure that comes in at the end will be so much cleaner.

I'm often asked if it's okay to leave the flash and camera set for rear-curtain sync all the time. Personally, I have yet to find a reason why you can't, although some may argue that if the camera was meant to remain in rear-curtain sync, then why didn't the manufacturers just make it so? It's a valid question, but I haven't seen any danger or bad flash exposures caused by being permanently set to rear-curtain sync. Even when shooting at the fastest "normal" sync speed (1/250 sec. in the case of Nikon), rear-curtain sync remains a good idea, because if there's any movement going on, the subject will always be illuminated at the end of the exposure, thus eliminating any possible ghosting or subject overlap. In addition, since you normally want to use rear-curtain (a.k.a. second curtain) sync when shooting in low-light situations, you'll have one less setting to fiddle with in the dark if rear-curtain is already engaged.

MY STUDIO IS LITERALLY RIGHT NEXT to the elevated train in Chicago. I thought, Since I have a front row seat to a Chicago icon, why not photograph it? I chose dusk to make these two images with rear-curtain sync in mind. With my camera mounted securely on a tripod and my flash set to first-curtain sync atop the camera's hot shoe, I judged the flash-to-subject distance to be about 11 feet. Based on this distance, my camera's meter indicated an aperture of f/18.

With my camera in Manual mode and the lens now set to f/18, I pointed the camera to the dusky blue sky above and adjusted my shutter speed until 2 seconds indicated a correct exposure. I now had both my natural light exposure and my flash exposure all set. I was ready for the approaching train. This is an eleven-car train, so I waited a few seconds as the first ten cars passed and then tripped the shutter release as the eleventh car went by.

Since I was in first-curtain sync, remember, the flash fired immediately at the start of the 2-second exposure. Over the remainder of the 2 seconds, the red and yellow taillights of the last car merged with the already-exposed train car (top). It's a messy exposure in which the "painted wood" had not had a chance to dry.

In the six minutes I had before the next train, I made several changes: I changed to rear-curtain sync mode. And since the flash would fire at the end of the exposure, I also needed to account for the train being farther away from the flash when the flash finally fired. I estimated that during this 2-second exposure, the train would travel from 11 feet to roughly 21 feet away from the flash by the time it fired. The flash distance scale indicated an aperture of f/11 for a correct exposure at 21 feet. With this aperture set on my lens, I took a new meter reading off the dusky blue sky (in six minutes the sky had gotten a bit darker), and a 2-second exposure was indicated. As the bottom image clearly shows, when the flash fired in rear-curtain sync at the absolute end of that 2-second exposure, the taillight streaks trailed that last car instead of starting in the middle of it.

Both photos: Nikon D300S, 24–85mm lens at 35mm, Speedlight SB-900. Top: f/18 for 2 seconds in first-curtain sync. Bottom: f/11 for 2 seconds in rear-curtain sync

THE KEY TO SUCCESSFUL PANNING

Panning is when you photograph any moving subject at a relatively slow shutter speed (such as 1/15 sec.) and stay focused on the moving subject while moving the camera in the same direction as that subject. This will often result in a relatively sharp subject against a background of blurry streaks. When you combine the use of your flash with these slow, panning shutter speeds, you not only get your background motion streaks, but you also get that extra "pop" of light on the main subject, which in turn makes it stand out.

The key to a successful rear-curtain sync panning exposure is that the background behind the subject must be busy and full of contrast so that the moving subject stands out. Panning against a clear sky is a wasted effort—a solid color won't offer up any interesting streaks when you move the camera. For your panning backgrounds, choose walls of graffiti, frame-filling city skylines, busy intersections filled with traffic, sidewalks along lighted storefronts and marquees, autumn-colored forests—you get the picture

DELIBERATELY COMPOSING THIS PASSING CAR
as it crossed one of the many bridges in downtown Chicago created a motion-filled image that relied on a slow shutter speed, panning, and rear-curtain sync. The trailing lights of the car are indicative of rear-curtain sync, but more than that, they're indicative of not panning at the same rate as the speed of the car. Had I followed the car with my camera at the same rate of speed, I wouldn't have had any trailing lights, since the lights would have been in the same spot in my overall composition throughout the exposure. Generally speaking, the perfect panning shot (usually made at around 1/30 sec.) will show the subject tack sharp and only the background blurry. But with the 1/2-sec. exposure you see here, I'm unable to keep the car perfectly positioned in the same spot in the frame as I move the camera left to right during such a long exposure. As a result, the car and lights are a bit wobbly. But I like a lot of implied motion in my panning shots. I also knew that at the end of the exposure, the flash would fire, further illuminating the car.

Nikon D300S, 12–24mm lens at 24mm, ISO 200, f/11 for 1/2 sec.

YOU DON'T HAVE TO BE LIMITED BY THE ABSENCE *of the more common, readily visible movement, since you can always create your own brand of motion. When both flash and available light are involved, the possibilities are truly endless. For example, shortly after moving into a new studio, my daughter Chloë and I decided to have some fun with Christmas-tree lights. I attached the string of fifty lights to a 1/4-inch piece of plywood with the intention of using them as a motion-filled, amusement-park-like background. As you can see above, I positioned the plywood with the lights against a wall and had Chloë stand about 10 feet away from them in front of a small softbox containing a single Nikon Speedlight SB-900.*

Based on the distance between Chloë and the softbox, my distance scale indicated an aperture of f/22. But since the flash would be passing through a softbox, I knew I'd experience some degree of light loss. How much? Most small softboxes will diminish flash output by about 1 full stop. In addition, I had placed a red gel over the strobe and that would account for another full stop of light loss (see page 138 for more on gels). With that in mind, I set the lens to f/11, recovering the 2 stops of light, and immediately took a test shot of Chloë. The result was a correct flash exposure of her face, but I also wanted to inject some motion and record colorful spinning lights in the background.

So I turned off the studio's overhead lights and pointed the camera at the Christmas lights. I adjusted my shutter speed until a 2-second exposure indicated a correct exposure with f/11. That would get me a correct exposure of Chloë and at the same time render a correct exposure of the spinning lights. (As long as the flash-to-subject distance was set for the correct aperture and the shutter speed was set for the ambient light of the tree lights, a correct exposure of both Chloë and the tree lights was ensured.) With my exposure set and my camera securely on tripod, I tripped the camera's self-timer for a 10-second delay. During this delay, I rushed to the end of the studio, picked up the 1/4-inch piece of plywood with the lights attached, and swirled it like crazy. Since the camera was set to rear-curtain sync, the flash didn't fire until the end of the 2-second exposure. The background result is reminiscent of a science fair or amusement park.

Nikon D300S, 105mm lens, f/11 for 2 seconds, Speedlight SB-900

SOMETIMES, OUT OF *nowhere it seems, I get these ridiculous ideas. While in a hardware store, I came upon a cheap metal chimney hood and thought about how silly it would look if someone were to wear it as a hat. Just a few feet away I spotted several metal cups. Then I thought about how cool it would be to glue them atop the chimney hood and create an "electrically charged" portrait.*

I called my friend John, who agreed to play the role of the mad scientist in this crazy composition. I fitted the metal "hat" on his head and placed my camera on tripod. Then on each side of John, I put a Nikon Speedlight SB-900 on a light stand, pointing each one into an attached umbrella. I also had John hold a silver reflector in his lap, facing up. So when the flash exposure was made, the light from both flashes lit each side of his face, while the reflector bounced some of the light from each flash up toward his face, filling in the area under his chin with light.

Based on my flash-to subject distance of 5 feet, I set my aperture to f/16, ensuring that my flash exposure would be correct. However, I also intended to create an "electrical charge" between the two cups by moving a sparkler through the area, and I judged that I'd need a 2-second exposure to get the right effect. With the aperture set for f/16, I set the shutter speed to 4 seconds. With the flash set on rear-curtain sync, I turned off all the studio lights, set the camera's self-timer for a 10-second delay, immediately got behind John, and then lit the sparkler. I placed the lit sparkler inside the metal cup on the left, and as soon as I heard the shutter open, I raised the sparkler out of that cup and started moving it quickly toward the other cup, jostling it in an up-and-down motion. Just before the 4 seconds expired, I pulled the sparkler behind John, out of view, and bent down behind him. At this time, both flashes fired, perfectly illuminating John's face for an exposure that combined the ambient light of the sparklers with the flash exposure of John's expression.

Nikon D300S, 105mm lens, ISO 200, f/16 for 4 seconds, two Speedlight SB-900s

ARRIVING AT VENICE BEACH *about thirty minutes before sunrise, we were greeted by a predawn sky. I was photographing the members of the band WaldoBliss and was quick to ask all four band members to walk atop some short log posts. I knew they would be set against a backdrop of palm trees and dusky blue sky. With my aperture set to f/5.6, I adjusted my shutter speed until the camera meter indicated 1/2 sec. as the correct shutter speed. I quickly set up a single strobe on a small light stand, and after dialing in my aperture (f/5.6), the flash indicated a flash-to-subject distance of 11 feet, so I placed the light stand about 11 feet directly in front of them. I asked them to walk slowly, and as they did, I fired the camera and quickly "jerked" it upward during the exposure. Since the flash was set for rear-curtain sync, I was able to record a ghosting blur of the trees and band members, knowing that, at the end of the exposure, the flash would light up and freeze the band members in perfect detail. This effect is often referred to as* dragging the shutter, *and as you can see, it's an easy technique. It has been my experience, however, that it seldom works consistently with shutter speeds other than 1 second, 1/2 sec., or 1/4 sec. Faster speeds don't allow enough time to record the ghosting effect, and slower shutter speeds allow too much ghosting to take place—so much so that the overall exposure looks muddied.*

Nikon D300S, 12–24mm lens at 12mm, f/5.6 for 1/2 sec., Speedlight SB-900

USING YOUR FLASH CREATIVELY

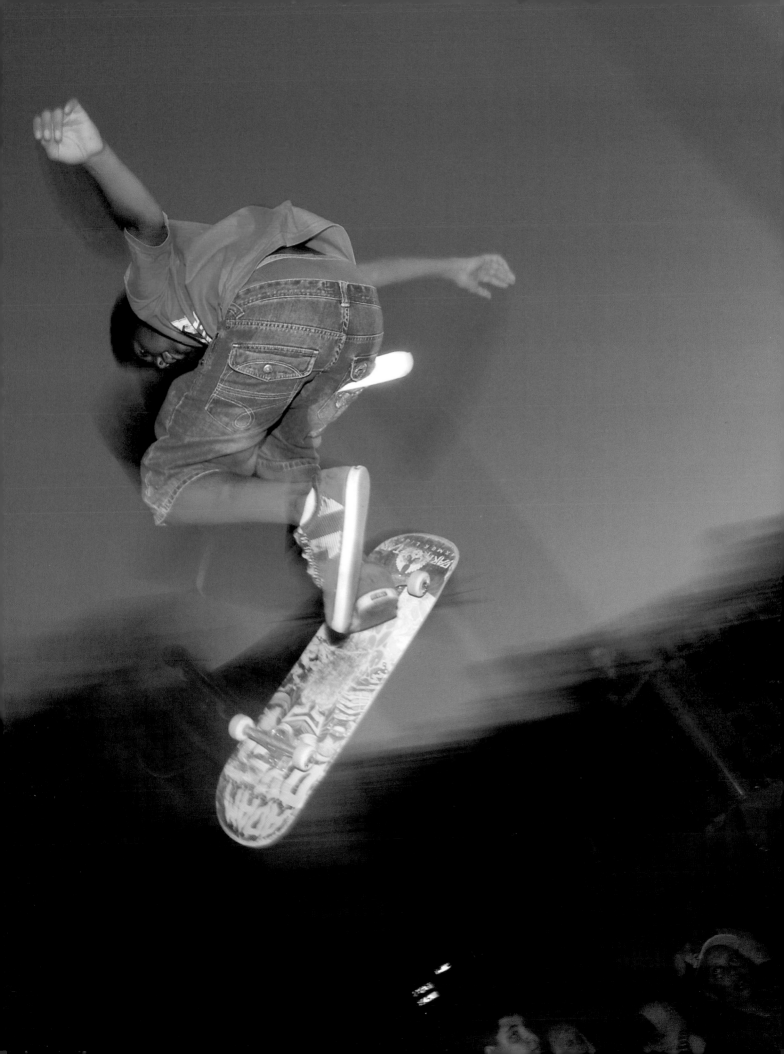

High-Speed Sync

Once you've got some practice with flash under your belt, you can branch out and really get creative. High-speed sync is a feature that lets you do just that. Let's say you and your family have planned a family outing in a nearby park where many colorful flowerbeds are pronouncing that spring has arrived. You'd love to get some nice portraits of your wife and kids, using the flowers as a wonderful backdrop of out-of-focus tones and colors. As is often the case, your spouse doesn't share your joy of rising at the crack of dawn and rushing out the door for excellent photographs. As a result, it isn't until about 12:45 PM that you all arrive at the park, and your family members want to get the "photo stuff" over with so that they can all just relax and enjoy themselves.

Oh, man, are you ever under the gun! Your family has no clue about light and photography, and explaining the principles of midday sunlight would only be an exercise in futility. They just want you to make it happen as quickly as possible, so let's make it happen—despite that harsh, midday light! Do you think wedding photographers get away with telling a bride she can't be photographed outside in the garden at midday because it's too bright? Heck, no!

This is where high-speed sync comes in. By now you know that to get the most power from your flash you must use it at the full-power setting of 1/1 and with a shutter speed no faster than the maximum sync speed. However, high-speed sync is a feature that allows you to use your electronic flash at shutter speeds much faster than the maximum sync speed. Ever since high-speed sync came on the scene, wedding and portrait photographers the world over have used it to shoot brides in scenic flower gardens at midday.

So there you are, midday, shooting portraits of the kids about 30 feet in front of the most colorful flowerbed you could ever imagine. Choosing an *f*/4 to render the background flowers out-of-focus tones and colors, your meter indicates a shutter speed of 1/5000 sec., due to the bright conditions surrounding you. And of course, the light overhead is harsh on your subject's faces. But no worries, as you call on your flash—mounted off camera—to create nice, even fill light on their faces. You frame up a good composition at a focal length of 105mm, and everything looks superb in your viewfinder. You're almost ready. You simply set the camera to high-speed sync and manually push the zoom button on the flash so that it registers 105mm. At ISO 200 and *f*/4 for 1/5000 sec., the flash distance scale indicates a flash-to-subject distance of 7 feet for a perfect exposure, so you place yourself 7 feet from your subject and bingo, bango, bango! You've done it: an impressive and beautiful portrait shot at midday. You're one smart cookie!

How the heck is it possible to suddenly shoot a correct flash exposure at shutter speeds that are much faster than the maximum sync speed? It's possible because electronic flash has a special talent. While it usually produces a single burst of light when shooting at the normal maximum sync speed, when operated in high-speed sync, the flash momentarily becomes a high-speed strobe light, firing multiple times (actually, hundreds of times per second) when using those superfast shutter speeds. With fast shutter speeds, as soon as the first curtain of your shutter begins to open, the second curtain is right on its tail, closing in very quickly on the first. While this narrow slit between the curtains moves across the digital sensor (or film plane), the high-speed synced flash repeatedly illuminates the scene (strobe-light style). Due to this pulsating light, the subject is exposed to the light of the flash, albeit through a ridiculously small slit in the curtain.

No doubt you're by now convinced of the usefulness of high-speed sync, making it one more powerful tool at your creative disposal. With Nikon and Canon cameras, you can leave high-speed sync engaged so that it's available for all flash pictures when you need it. When high-speed sync is turned on, you can take a flash picture at any shutter speed, at any time—and without thinking about your designated sync speed. You may be thinking, I never have to worry about anything ever again and can shoot away. This idea makes sense in theory, but I wouldn't recommend it. If you take a look at the facts and figures mentioned in the box opposite, you'll see that simply turning on high-speed sync automatically cuts your guide number almost in half. That's a lot of lost power, especially if you don't really need high-speed sync for what you're shooting. Let's say that you accidentally change your shutter speed from 1/250 sec. to 1/1000 sec.. At 1/250 sec. your guide number was 160, but at 1/1000 sec. it's now 40. Accordingly, your subjects can be no farther than 5 feet from the flash for a

ACTIVATING HIGH-SPEED SYNC

Canon calls its high-speed sync feature High Speed Sync (HSS) on its 580EX flash. Nikon calls it Focal Plane (FP). With either system, you must first activate this feature to sync your flash with superfast shutter speeds. In Canon's case, you activate the feature on the flash with the press of a button (refer to your flash manual for the exact instructions). With Nikon flashes, you go to Camera Menu and select Custom Feature; scroll down to Bracketing/Flash, and then choose Sync Speed 1/320s. After I set my Nikon D300S to that 1/320s sync speed, the back of my flash shows the FP icon, assuring me that I am indeed operating in high-speed sync mode.

correct exposure. If you're shooting a portrait from 15 feet away with your flash attached to your camera, your flash output will be too weak to illuminate your subjects. While high-speed sync is a wonderful feature, it can trip you up if you leave it on for all of your shooting. Consider using it only when necessary, and turn it off when it's not.

When you keep in mind that much of what can be done with a flash outdoors *should* involve the use of the ambient light, you'll soon come to the same conclusion that I did some time ago: Every minute of the day or night affords an opportunity to use your flash. I never really thought I would hear myself saying that! Until recently I was a big fan of chastising anyone for shooting during midday light, suggesting instead that we all meet at the pool and work on our tans, but of course we now know that even during midday—and especially with high-speed sync—great flash photography can be achieved. In fact, that's one of the greatest reasons to embrace flash.

HIGH-SPEED-SYNC CAVEAT

Are there any downsides to shooting in high-speed-sync (HSS) mode? Only one, really, and it has to do with the flash output power. While high-speed sync fires a series of stroboscopic bursts at an extremely quick rate, the flash output of each burst is of lower flash output power. The lower output is what allows speeds of 1/8000 sec. or more. This reduced flash output averages around 1/2 to 1/4 the output of full-power (1/1) flash. Essentially, each time you quadruple your shutter speed, you cut the guide number (page 58) in half. Here are some figures, and you can see the reductions:

SHUTTER SPEED	APERTURE	FLASH MODE	RATIO	FLASH RANGE	FLASH MODE	GUIDE NUMBER
1/250 sec.	f/16	Manual	1/1	10 ft.	Normal	160
1/250 sec.	f/16	Manual	1/1	10 ft.	HSS	80
1/500 sec.	f/11	Manual	1/1	7 ft.	HSS	60
1/1000 sec.	f/8	Manual	1/1	5 ft.	HSS	40
1/2000 sec.	f/5.6	Manual	1/1	4 ft.	HSS	30

Do you really have to do this math? Nope. Just get back to that flash distance scale; it will tell you all you need to know. With less power in high-speed sync, you need to be much closer to your subject than normal to generate the same effect of a full-power flash exposure. How much closer? That will depend on just how fast your shutter speed is, but know this: The faster the shutter speed, the shorter the flash-to-subject distance. You can see this by simply placing your flash on the camera's hot shoe with both the camera and flash turned on and with the flash set to high-speed sync. Set the aperture to f/8, and start cranking up the shutter speed dial on your camera. Watch the flash distance scale indicate shorter and shorter flash-to-subject distances as you increase your shutter speed from 1/250 sec. to your fastest available shutter speed.

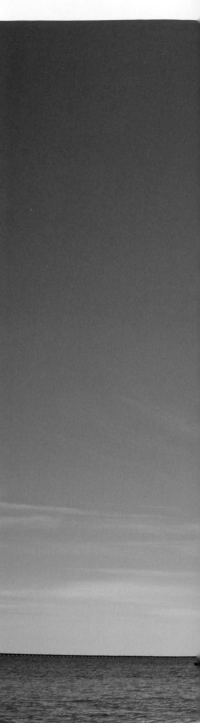

DURING A RECENT WORKSHOP IN TAMPA, *my students got to try their first of many high-speed-sync photographs. Our model Deana made numerous leaps for us, and because Deana would be flying by all of us from right to left, we definitely wanted to use a faster shutter speed to freeze the action. When I recommended at least 1/4000 sec., several students were quick to ask, How the heck are we going to do that when my fastest flash sync speed is 1/200 sec.? All my students that day had the Canon Speedlite 580EX II, but they had no idea their flash offered high-speed sync.*

So with their shutter speeds set to 1/4000 sec., I told them to take a natural-light reading of the strong backlit sky. An aperture of f/5.6 was indicated. I then asked what distance their flashes indicated for f/5.6. At ISO 200, it was approximately 4 feet. I told them to get down in the sand and prepare to shoot upward, and I marked a spot in the sand approximately 4 feet from them and their flashes (which were mounted on camera). That would be Deana's launch point for her leaps, as you can see opposite top. The image opposite bottom shows a natural-light exposure without flash, but above, you can see the benefit of high-speed-sync flash.

Above: Nikon D300S, 12–24mm lens at 16mm, ISO 200, f/5.6 for 1/4000 sec., Speedlight SB-900

WOULDN'T IT BE GREAT TO BE ABLE to shoot backlit outdoor subjects that are beautifully lit by your flash but that also record a correct exposure of very bright and powerful backlight? Well, as we just discussed, it is possible to do just that with the aid of high-speed flash sync, but some flashes don't offer this feature. There is another solution when you're faced with "impossible" ambient-light exposures that are normally out of the range of the fastest sync speed—and that solution comes in the form of a neutral-density (ND) filter.

Shooting from a low angle with my wide-angle lens, I framed these tulips in the foreground while shooting up to the east into the mid-morning sky and sun. With ISO 200, my exposure was f/11 for 1/2000 sec. This reading came as no surprise, because the superbright background heavily influenced the light meter. When I shot at these camera settings without flash, I recorded a nice exposure of the sun and sky, but my flowers were quite dark (above, left). Setting an exposure for the flowers (f/11 for 1/60 sec.), however, resulted in an overexposure of that much stronger background light (above, right).

Since I wanted to record a correct exposure of the flowers as well as the sun and sky, and since I wanted to maintain great depth of field for a storytelling image, I had but one reasonable choice: use my flash and light up those flowers to be the same exposure as the sky and sun. Simple math told me that under normal circumstances I

couldn't use my flash because I was determined to use the exposure for the sky and sun, which was, again, f/11 for 1/2000 sec. For most cameras, 1/2000 sec. is beyond the fastest sync speed—unless you use high-speed sync or an ND filter. I chose the latter in this case.

Immediately after placing my 3-stop ND filter on my lens, my meter indicated an exposure of f/11 for 1/250 sec. for the sun and backlit sky. Certainly 1/250 sec. is well within the range of a normal sync speed. After powering down the flash to 1/32 power, the distance scale indicated that at f/11 the flash would cover a distance of just around 2 feet. That worked for me, since I was using my full-frame fish-eye lens for this composition and wanted to get about that close to those large, colorful tulips. And since I was shooting in the vertical format, I removed the flash from the hot shoe and used it with a sync cord. I held the flash above the foreground flowers from a distance of about 2 feet and tripped the shutter release. I was then able to record a daylight exposure of my foreground tulips without sacrificing my daylight exposure of the sun and sky—all because I used an ND filter!

All photos: Nikon D300, 14mm fish-eye lens, ISO 200. Above, left: f/11 for 1/2000 sec. Above, right: f/11 for 1/60 sec. Opposite: 3-stop ND filter, f/11 for 1/250 sec., Speedlight SB-900

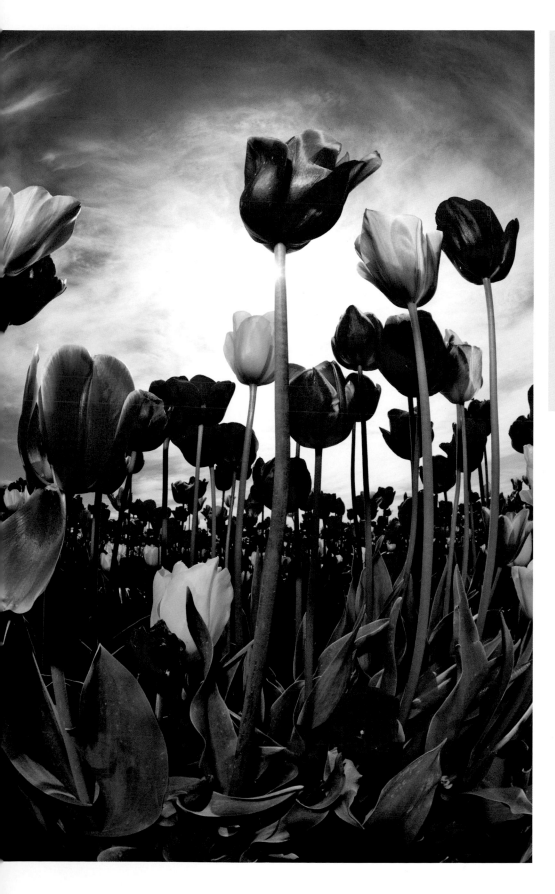

WORKING WITH A NEUTRAL-DENSITY FILTER

A cheap and viable alternative to high-speed sync in many situations is to use a neutral-density (ND) filter. The neutral-density filter simply reduces the intensity of the light that passes into your lens, as if your camera is wearing sunglasses. This, in turn, causes your light meter to offer up a much slower shutter speed for the scene before you. A neutral-density filter will typically force you to drop your shutter speed by 3 or 4 stops (depending on the filter model), and more often than not, that reduction in light will be enough to return you to the more familiar flash sync speeds offered by your camera.

Zooming the Flash Head

You've surely noticed the references I made earlier to zooming your flash. If you haven't already discovered this really cool feature on your flash, you'll want to do so right now. Just like the telephoto zoom lens that brings subjects closer to you, the zoom on your flash is meant to push light farther. Let's say you want to photograph your daughter standing 25 feet away under the shade of the maple tree using your telephoto zoom at the focal length of 105mm and illuminating her with your flash. How are you supposed to do that? You're going to *zoom the flash head* so it matches the focal length set on your lens, that's how.

Zooming the flash head causes the beam of flash light to narrow. When the beam of the flash narrows, the flash's light travels farther. It's a lot like water through a garden hose. Without the benefit of a nozzle, water gushing out of the hose can only travel so far. With a nozzle on the hose forcing the water through a narrower opening at an increased pressure, the water travels a lot farther. Flash light doesn't have pressure, but it does gain intensity when focused into a narrower beam. When you narrow the flash beam, the more-focused light travels a greater distance rather than spreading out and dissipating.

When you start playing around with the zoom on the flash, you'll quickly see just how that angle of the light output can go from wide to narrow. So again, the narrower the angle of the flash head (or the more "zoomed in"), the farther the light output can travel in one direction. Just don't expect this zoomed-in flash to light up a four-lane freeway, since the flash will be traveling down a much narrower road.

Now, you may have noticed that your flash head has a feature that zooms it automatically as you change the focal length of your lens. Well, I'm here to tell you to disable this feature. Why would you disable it? Because when it's enabled, your flash head follows your lead and changes its angle of view whenever you change the focal length of your zoom lens. This is useful if you're shooting a fast-paced event during which you're constantly zooming in and out. However, this feature only works when the flash is mounted on the hot shoe or attached to the hot shoe via a cord. Since you'll want to use your flash off camera in many situations, it's best to disable the auto-zoom feature on the flash. Manually setting your flash zoom will also allow more creative freedom for exposures in which you might not want your flash zoom setting to match your lens focal length—for example, when you want to illuminate deeper into a scene than your angle of view for a particular effect. So open up your flash menu, and turn off the auto zoom, thereby ensuring that you will manually set your flash zoom for each shot.

WHEN I TOOK THIS SHOT, the Chicago weather forecast had called for yet another worthy winter snowstorm, and since I had missed the last worthy Chicago snowstorm while on a trip to New Zealand, I was determined to try my hand at flash in this storm. I had this idea to capture falling snowflakes against a dawn sky that would also include one of my favorite trees in a nearby park. All I needed was some light snowfall and a willingness to rise before dawn.

Now you might be asking yourself, How is it possible to have a dawn sky of any color when it's snowing? I wasn't expecting a clear dawn sky but the typical gray sky that one gets with snowfall, but I also knew that at this early hour even a gray sky would record a bluish hue. The bonus on this day was a really small sliver of clear sky on the horizon, somewhere over Lake Michigan; this got me some subtle magenta near the bottom of my composition.

So there I was, lying in the snow with my camera on tripod and my 12–24mm lens at a focal length of 20mm. With my aperture set to f/5.6, I focused on the tree and adjusted my shutter speed until 1/15 sec. indicated a correct exposure. All that remained was to fire up the flash in Manual exposure mode, setting it to f/5.6 at full power and then setting the zoom of the flash to 105mm. Now why would I set the zoom of the flash to 105mm when shooting with my lens at 20mm? Because I wanted the flash to travel farther into the scene, illuminating snowflakes that were both close to me and farther away. This, in turn, created far more depth than if my flash were set to the 20mm focal length. The resulting image almost looks like one of those star-trail time exposures or even a meteor shower. Just another example of having fun with a single flash!

Nikon D300, 12–24mm lens at 20mm, f/5.6 for 1/15 sec., Speedlight SB-900

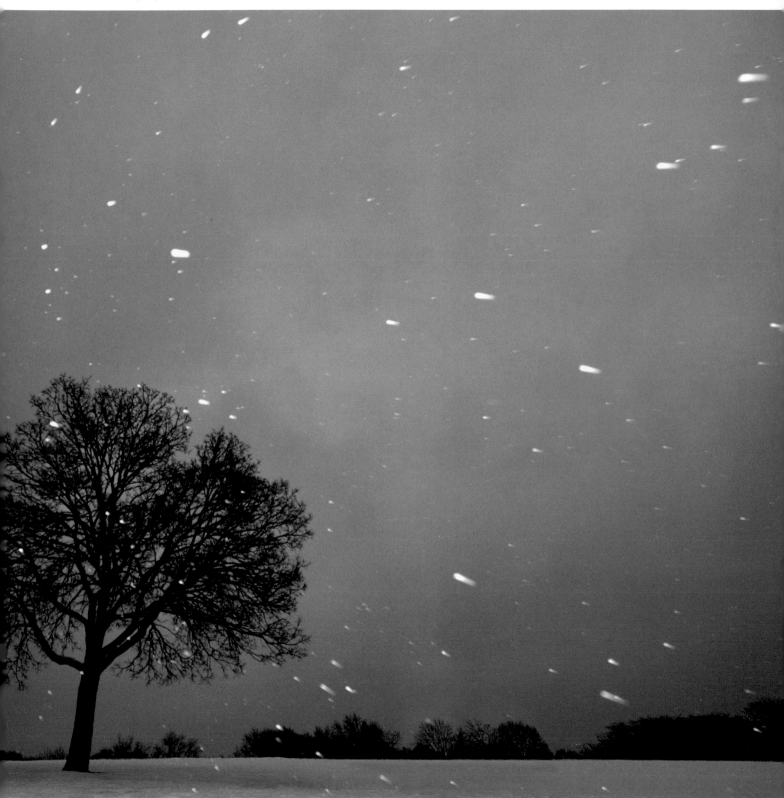

HE'S CALLED THE WIZARD of Christchurch, and just like clockwork, he shows up in his wizard costume, along with his 6-foot wooden ladder, in the town square of Christchurch, New Zealand, every day at 2:00 PM—rain or shine. Over the course of the next 45 minutes, he dispenses a great deal of advice on subjects ranging from sex to war to politics to religion. He is not only entertaining, but if you listen closely, much of what he says is actually insightful. When I saw the Wizard in the winter of 2010, I, like so many others before me, quickly succumbed to the temptation to photograph his wisdom-filled face, and I set up about 20 feet away from him (top, left).

This particular day was quite overcast, so I opted to use my flash along with an amber gel to get a much warmer Wizard portrait. I needed to shoot wide open, because I was handholding the camera for this shot, and you get the fastest possible shutter speed when the lens is wide open. With the 70–300mm zoom lens I was using, at the 250mm focal length I wanted, that meant f/5.6. Considering the heavy overcast sky, I was in no danger of my shutter speed exceeding the maximum sync speed. So at 250mm, ISO 200, and f/5.6, the camera meter indicated a shutter speed of 1/160 sec. for a correct daylight exposure.

I then zoomed the flash head all the way to its maximum of 200mm. I dialed in my aperture of f/5.6, and the distance scale told me I needed to be at 41 feet! Yikes! I was a heck of a lot closer than that—about half that distance, in fact. But neither the flash nor the distance scale knew I was using an amber gel on my flash or that the flash was in a softbox. These factors combined to reduce the flash output by about 2 stops. That loss of flash output meant I needed to choose a distance that would be equivalent to 2 stops less power. So I dialed down the flash's aperture wheel 2 stops and saw that f/11 was good for a flash-to-subject distance of 20 feet. Hot-diggity, I was at 20 feet! So even though I was shooting at f/5.6, I used the distance for an aperture of f/11 because my softbox and gel cost me about 2 stops of exposure.

Finally, because I wanted to underexpose the ambient light a bit, I chose to shoot at a 1/250 sec., knowing that my flash would provide the "daylight" exposure on the Wizard's face. When the Wizard paused his animated speaking momentarily, I fired off the shot opposite and was quite happy with the result. I then turned off the flash, brought my shutter speed back down to a correct natural-light exposure of 1/160 sec. and fired off another shot (bottom, left). Comparing the two, I think the flash exposure provides a more flattering image because of the added warmth and sparkle in the Wizard's eyes.

Both photos: 70–300mm lens at 250mm, ISO 200. Opposite: f/5.6 for 1/250 sec., Speedlight SB-900. Left: f/5.6 for 1/160 sec.

Wireless Flash

As you've no doubt surmised by now, using your flash off camera is really the way to go. Imagine the possibilities if you had several flashes and you could place them *anywhere* in your scene and use them to simulate *any* kind of light. The ability to use multiple flash units—all triggered wirelessly—increases your creative options exponentially. Wireless flash has unlimited potential, so let's take a look at how it works.

Flash units that aren't connected to the camera by a dedicated sync cord need to be triggered wirelessly to flash at the appropriate time. There are many devices available for triggering your off-camera flash, including sync extension cords, optical slaves that "see" the other flashes fire and trigger the one they're attached to, radio remotes, and designated devices. Today's newer flash units come with wireless flash capability built in; these systems can trigger as many flash units as you have, provided they're all compatible with your system.

The advantages to dedicated wireless units are (1) having no wires between the camera and flash (or flashes), (2) the ability to place the flash (or flashes) a great distance from the camera, and (3) through-the-lens (TLL) features that can adjust each flash unit's output levels right from the camera. (For the TTL features, you need one master flash or triggering device and some flash units acting as slaves. With Canon dedicated units, you place the master flash unit in the hot shoe and slide the switch to Master; the master will then trigger all the other units in your lighting setup that are set to Slave. Nikon works similarly, with a master unit in the hot shoe to trigger the slaves. Newer camera models with pop-up flash have a feature that allows the pop-up flash to be used as a master flash that triggers slave flashes, a menu option that is sometimes called Commander.)

To recognize the master signal, each slave unit is assigned an ID, allowing its power output to be adjusted right from the camera. Imagine being able to adjust your key flash and fill flash, no matter where they are and all from the camera! Also, if you have a flash in the hot shoe or are using the pop-up as the master unit, that master can

THE TOWN SQUARE IN CHRISTCHURCH, NEW ZEALAND, *is filled with a host of characters on most any day, but as is true with most cities and towns, the abundance of characters are found on the weekend. This particular man caught my eye as he passed by me on his unicycle while juggling three red balls. I made a point of getting his attention and engaged him in conversation. After a while, I asked him if I could take his photograph and he, obviously, agreed.*

Considering his long hair and beard, he was a candidate for what I call a sunset-portrait-on-the-beaches-of-Hawaii shot. You may be familiar with portraits that are actually shot against the bright backlight of a sunset on the beach, but did you realize that you can replicate that same ambient exposure with a flash—and even do so when you're miles away from the beach? Take a look. In the first photo at left, I've got the composition of my frame-filling portrait set, and handholding the camera, I set my aperture at f/8 and adjusted the shutter speed until the camera's light meter indicated 1/125 sec. as a correct exposure from the light reflecting off his face.

For the second photo, I called on the aid of my flash with the same exposure, but note the bright backlight of the "sunset" behind him and how his hair is aglow. How did I do that? I first set an aperture of f/8 on the flash and found that at full power I'd need a flash-to-subject distance of 12 feet for a correct exposure. However, a correct exposure was not what I wanted here. In fact, I wanted the flash exposure to record as an overexposure so that the eye/brain would be fooled into thinking there was a sunset behind the subject. I knew that if I placed the flash about 3 feet behind the subject's head (pointing toward him), a gross flash overexposure would result. With one PocketWizard attached to my flash and another mounted on the camera's hot shoe, I was able to fire remotely, and I had one of my students hold the flash in position, 3 feet behind the subject. A backlit sunset portrait was the results.

Both photos: 70–300mm lens, f/8 for 1/125 sec, ISO 200. Opposite: with Speedlight SB-900

be set to act *only* as the trigger for the other units in your setup—without outputting any flash light.

If you'd rather not dedicate an expensive portable electronic flash as the master triggering unit and your camera doesn't come with a Commander feature, you can use the manufacturer's dedicated infrared (IR) triggering devices. Canon and Nikon both have devices that you mount to your camera to serve as triggers to wirelessly control your off-camera flashes. Just remember, you don't need these IR triggers if you always have one of the flashes on camera acting as master. The IR trigger just offers a lower-cost alternative to using a flash to trigger the slave units. That way you can use your expensive flash units off camera to illuminate your composition as creatively as possible.

There are some drawbacks to IR triggers, and one is that when used outside in bright sun, they aren't always reliable, as the sun interferes with the IR signal. Also, when used outside, the trigger must be in a slave unit's line of sight for the slave to receive the IR signal. This eliminates setups in which you hide a flash behind an object. Indoors, this isn't a problem, as the signal can bounce off walls to reach the slave, but outdoors it becomes a challenge. IR triggers are also limited by the required distance between trigger and slave. So before you invest heavily in these devices, be sure to do your research. Many pros using wireless portable-flash systems prefer the wireless radio remotes over IR devices, because the radio signal doesn't require a line-of-sight or suffer from distance issues.

There are many manufacturers of radio remote devices for wireless triggering, including PocketWizard, Quantum, RadioPopper, and MicroSync. One word of caution is that you research the devices thoroughly. Some triggering devices can't sync fast enough to be used in high-speed sync situations; this means the camera shutters close before the flash burst is complete.

Wireless flash technology has become the rage, and many established pros are leaving their heavy studio lights back at the studio in favor of lighter, wireless flash kits when photographing on location. For example, portable flash can easily work as key light and fill light, a combination that works very well for portraits even outdoors. The key flash is placed off to one side so that the light wraps across the subject and sculpts the face by creating light and dark; an additional flash (or flashes) can then be added to create fill flash that lowers contrast and fills in shadow areas. If you have enough portable wireless flash units, you can also add a hair, edge, or background light for more accents on your subject.

HERE'S ANOTHER EXAMPLE OF CREATING *that backlit sunset effect, and I'm including it so that you can see the setup above. In this covered parking garage, the camera meter indicated an exposure for the model's face of f/8 for 1/125 sec. based on the ambient light. Great friend and photographer Robert LaFollette agreed to be my VAL (voice activated lightstand), an acronym coined by the iconic flash master Joe McNally. Robert stood close behind our model, about 3 feet from her, and held up the flash, which I had covered with an amber gel to provide the warm, sunsetlike tones.*

With my flash and camera set to Manual, and with the flash powered down to 1/2 power, the flash distance scale told me I needed to shoot at f/16. However, in this case, I wasn't going to use f/16 but rather f/8. But wait—using f/8 would mean that the flash exposure would be 2 stops overexposed, wouldn't it? Yes, it would, but I had a really good reason for wanting the flash exposure to be overexposed, as you'll soon see.

First, though, I needed to set a correct exposure for the model's face. With my aperture set to f/8, I zeroed in on her face and adjusted the shutter speed until my camera's meter indicated a correct exposure at 1/125 sec. Sure enough, when I tripped the shutter release, the flash fired behind the model's head, and in that instant, I recorded a correct exposure of the natural light reflecting off her face. At the same time, I recorded a 2-stop overexposure around the edges of her hair, which was illuminated by the flash behind her head. The edges of her hair were overexposed, as I intended. The reason I wanted that overexposed look was to get that sun-going-down-behind-her look. If this were the real sun setting behind her, it, too, would record as a 2- or 3-stop overexposure (assuming, of course, that you had set an exposure solely for the natural light falling on her face). It really is this easy! And now that you know this, go grab your significant other or the kids. It's time to pretend the sun is going down behind them!

70–300mm lens, f/8 for 1/125 sec., Speedlight SB-900

DO YOU NEED A SPECIAL FLASH TO ILLUMINATE *your friend standing among the trees at dusk along the shore of Chicago's Lake Michigan? It may appear that way, but the fact is, you can easily make this very simple shot with one portable electronic flash. Although I was over 150 feet away from my subject, my flash was not. In fact, with palms outstretched, my subject was holding the flash pointing up at himself. The Speedlight SB-900 in his hands was connected to a small radio remote that he was also holding. With another PocketWizard mounted on my camera's hot shoe, the two could now "talk" to each other, and once I pressed the shutter release, the flash fired.*

Remember, correct flash exposure is 100 percent dependent on the right aperture choice, and the right aperture choice is always determined by the flash-to-subject distance. My distance from the subject is meaningless, unless I'm shooting with the flash mounted on the camera's hot shoe. I estimated that when my friend held the flash out in front of him, the distance from the flash to his face was about 2 feet. So that's my flash-to-subject distance. I also took into account that I wanted to record the ambient-light exposure of the dusky blue sky and the surrounding trees. Did I have any depth-of-field concerns? No, not really, since the trees and my friend were basically at the same focusing distance. So I used a "Who cares?" aperture of f/8. When I set f/8 on my flash, the distance scale told me that at roughly 1/64 power my flash would illuminate a subject 2 feet away.

I then gave my friend the flash, along with an attached PocketWizard radio remote, and had him walk 150 feet into the scene. I also put a PocketWizard on my camera's hot shoe and mounted the camera on a tripod. I set my aperture to f/8 and, while pointing my camera to the sky above the trees, took a meter reading and adjusted my shutter speed until 1/2 sec. indicated a correct exposure.

Nikon D300S, 12–24mm lens, f/8 for 1/2 sec., Speedlight SB-900

ON A CAMPING TRIP WITH MY FRIEND *Charlie Borland, we decided to shoot a camp scene with wireless flash. He placed the flash inside the tent with the flash zoom manually set to a wide angle. This flash unit also had a wide-angle diffuser to spread the light around the tent. To keep the flash output consistent with each flash burst, he set the flash mode to Manual and the output to 1/4 power. This allowed an aperture of f/8. My strategy was then to shoot every single shot at f/8—giving the tent a consistent flash exposure—but bracket the shutter speed all over the place. This provided some darker and lighter ambient exposures of the mountain, people, and campfire, while the tent always had the same flash exposure. This particular shot had just the right mix of light and dark, with a well-exposed tent. Photo by Charlie Borland*

Canon 20D, 70–200mm lens at 200mm, ISO 200, f/8 for 1/4 sec., Canon 580EXII

FOR YEARS I ENJOYED SHOOTING A TWO-LIGHT SETUP with my two White Lightning Ultra 1200 studio strobes, placing each in a softbox—one on the floor, pointed up, and the other on a light stand, pointed down. Between these two softboxes would be a 4 x 4-foot sheet of 1/8-inch white Plexiglas on which I'd place numerous subjects, including flowers and fruit and vegetable slices. The image above is an example made this way. But as much as I enjoyed this setup, it did take up a large corner of a room, and it was expensive.

Then one day I stumbled upon the obvious. I lined the inside of a medium-size cardboard box with white poster board, replicating a softbox. I put one portable electronic flash inside the box, pointing it up. On top of the box, I placed a sheet of 1/8-inch white Plexiglas. And I mounted another portable flash on a light stand overhead about 2 feet above my subject. Doing this (opposite, top left), I was able to create a scaled-down version of my old larger setup with studio strobes and softboxes. Some kind of wireless device is key here to get the strobes to fire simultaneously. Due to the obstruction of the flash in the box, I've found a radio remote, such as a PocketWizard, to be most successful.

To start, set both flashes to the same output—full power. Also make sure that both flash distance scales indicate the same f-stop. F/16 is a good place to begin. Keep in mind that the flash in the cardboard box will be illuminating the subject through the 1/8-inch Plexiglas, so don't place a diffuser or any other light-filtering device on the strobe going into the box, since the Plexiglas becomes the diffuser. However, do place a diffuser on your other flash so that its light output is also diffused. Next, call on a normal sync speed of 1/125 sec., 1/200 sec., or 1/250 sec.; that choice is yours. Then place a flower or other small subject on the Plexiglas, and shoot down on the setup.

Check your exposure. Your goal is a subject floating in white space while being well exposed from both front and back. Many subjects will appear to glow. This is due to the strong backlight of the strobe firing from inside the box. You may end up decreasing the power of one strobe to make it mesh more with the light output of the other. It's easier to make any changes to the strobe outside the box (the one on the light stand).

For the bottom flower image opposite, I took apart a regular bouquet, arranged it on the Plexiglas, and set my aperture to f/11. The flowers appear to float, and the combination of backlight and frontlight creates great contrast. For the three tulips (opposite, top right), I used the same exposure settings. As you can see, the two different setups produce identical results.

All photos: 105mm lens, ISO 200, f/11 for 1/125 sec.

Direction and Shape

Throughout this book, there are numerous references to using the flash off camera and to the right of, to the left of, from below, or from above the subject. Unlike the sun, which follows a fairly predictable line across the sky as it moves toward sunset, your flash can be placed anywhere you need light. Yet—just like the sun—your flash emits "daylight." And your flash can mimic all the varieties of sunlight: the hard light of midday, the soft light of an overcast day, or the warm front- or sidelight of an early-morning sunrise. Your flash can also provide backlight, silhouetting a subject in front of it or even looking like a sunset when placed behind a subject's head and used with an amber gel.

I know of no better exercise that will help you immensely in understanding the daylight output of your flash—and its direction—than one that I always recommend to my students. If you can't find someone to be your model, then use a simple vase of flowers on a table. From a distance of about 15 feet from your subject, and with a moderate telephoto lens such as an 85mm, set the aperture on your camera to f/16. With your flash in Manual mode, zoom the flash head to 85mm and set the ISO to 200. Now dial up f/16 on your flash and note the distance required for a correct flash exposure. Let's assume that distance is around 12 feet (*Note*: It may or may not be, depending on the power of your flash.)

As you face the subject from 12 feet away, think of your position and the subject's position as the hands of a clock. Your subject is at twelve o'clock and you're standing at six o'clock. From the correct flash-to-subject distance, take your first picture with the flash at this six-o'clock position. This is a *frontlit* scene, meaning your subject is in *frontlight*. Keeping your camera in its place, if you move your flash to the nine-o'clock position and then the three-o'clock position (keeping that 12-foot flash-to-subject distance), you'll have *sidelit* scenes, with the subject in *sidelight*. Finally, if you move just the flash to the twelve-o'clock position (12 feet behind the subject), you'll have a *backlit* scene, since the subject will be in *backlight*.

Study your resulting photographs and you'll quickly notice a difference in the lighting. Make a note of what you like and don't like about the light's effect on the subject in each of these four exposures. As you begin to experiment more with flash and become familiar with how light falls across a given scene or subject based on your flash placement, you'll soon be making mental images of the scenes before you without having to even set up the shot. Knowing your flash, the power of its output, and how it looks from different angles will not only save you precious time when setting up shots but will increase your odds of pulling off some magical and very creative images. The only limitations are those of your imagination.

WHILE IN A NEIGHBORHOOD *of Tucson, I came upon a home with a gated entry that was, I'm sure, meant to be a piece of art. Assembled from a number of metal pieces—all varying in size, shape, and texture—it could easily be photographed to showcase the effects of light on a subject. Focusing on just a portion of the gate, I set up with my camera mounted on a tripod and shot four different manual flash exposures: one pointing the flash down from above (opposite, top), one pointing it up from below (opposite, bottom), one with it on the right of the subject (left), and one with it on the left of the subject (below). Although I never once changed my camera position, it is evident that each exposure is unique. That uniqueness has everything to do with the light and its direction.*

All photos: Nikon D300S, 12–24mm lens at 24mm, ISO 200, 1/40 sec. at f/22, Speedlight SB-900

MOVING BEYOND A SIMPLE METAL GATE, *try your hand at various lighting angles with a human subject. It's a truly revealing exercise in how the direction of the light has a tremendous impact on the emotional appeal and message of the image.*

In my first example (above, left) of a young Indian woman, the exposure is just of the ambient light. I positioned her under an overhang against a fabric-covered wall. The soft ambient light allowed me to record a simple yet pleasing portrait at f/8 for 1/60 sec. Now compare this with the next three images I made, which were all shot at the same exposure of f/8 for 1/250 sec. with flash. (I chose 1/250 sec. because I wanted to kill the ambient exposure, and after powering down the flash to 1/16 power, I found I could use f/8 at a flash-to-subject distance of 4 feet.) The only difference among them is the position of the flash and the direction of its light.

I had one of my workshop students hold the flash for me and set the camera to Commander mode for remote flash firing. I then had the student hold the flash in the twelve-o'clock position (above, right), the three-o'clock position (opposite, left), and the six-o'clock position (opposite, right). The overall feel and mood of each shot is quite different, and this diversity is owed 100 percent to the position of the flash. Get in the habit of moving that flash around the subject, and you'll soon be making a host of discoveries about light and its emotional impact in a photograph!

All photos: 70–300mm lens. Above, left: f/8 for 1/60 sec. Above, right, and opposite: f/8 for 1/250 sec., Speedlight SB-900

IN MY NEVER-ENDING QUEST *for letters, I now find myself calling on flash when I come upon raised letters, as I did during this outing in downtown Chicago. It was an overcast day, and I wanted to shoot in low-angled sunlight. No problem. This letter T was soon basking in warm sidelight thanks to a low-angled flash with an amber gel. Also, I didn't want the normally hard light of a low-angled sun, so I shot the flash through my circular cloth diffuser, as you can see at left. The result has depth and shadow—exactly like sunlight in the late afternoon.*

Nikon D300S, 105mm lens, ISO 200, 1/250 sec. at f/16, Speedlight SB-900

CREATING APPEALING *sidelight (opposite) was just as easy as asking my friend Yousif to pose among this long row of columns. With a single amber-gelled flash unit mounted on a small light stand and placed about 10 feet off to the right of the columns, I was able to create the illusion that Yousif was bathed in low-angled sunlight—even though it was a cloudy day.*

Nikon D300, 70–300mm lens at 300mm, f/11 for 1/60 sec., Speedlight SB-900

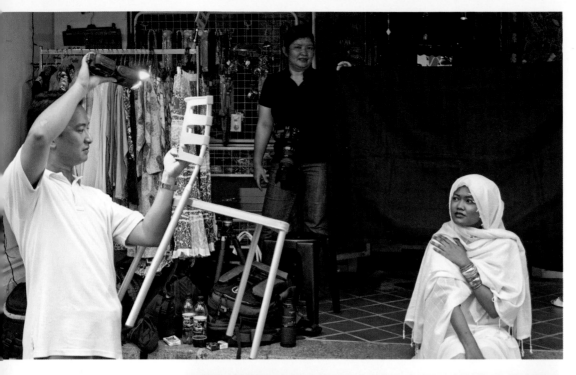

MY STUDENTS AND I WERE hanging out near Arab Street in Singapore when this pretty young woman came our way. When she agreed to be photographed, we quickly set up a black cloth behind her (left) to create a clean, black background. I then captured the first image below under the available light of the overcast sky. It's a nice shot, but I was in the mood for some low-angled sunlight and that really warm glow you often see streaming into your house through a window in late afternoon. And despite the overcast sky and the fact that we were outside, I knew I could create this look with my portable electric flash, a plastic chair, an amber gel, and the help of my students.

As the next image (opposite) shows, I got my subject appearing as if bathed in a single ray of warm afternoon light while looking "out the window." How did I accomplish this? I asked one student to hold the chair and the strobe, placing the strobe up and near the open slats of the chair back (above left). This essentially feathered the light, narrowing its angle of view via the slats in the chair. Only a portion of the light from the flash got through to the subject—just enough to create the warm ray of light you see here falling on her face.

With the camera in Manual exposure mode and the flash set to TTL, I simply aimed, focused, and fired. Since I shot this image in TTL and since the flash was off camera, I used Nikon's Commander mode to fire the flash. With my Nikon D300 camera, the pop-up flash became a transmitter, sending a signal to my flash to fire when the shutter was released.

Opposite: Nikon D300, 24–85mm lens at 85mm, ISO 200, f/8 for 1/200 sec., Speedlight SB-900

Colored Gels, Diffusers, and Snoots

A PURPLE GEL IS ALL IT TOOK *to turn a somewhat distracting foreground into a foreground with impact! Near the Marina Hotel and Casino in Singapore, a very interesting pedestrian bridge crosses the bay in the downtown area. The bridge's chrome structure affords photographers the opportunity to use elements of the structure to frame the distant skyline, but when shot at dusk (opposite), these parts of the bridge are often "dusted" with a smattering of streaks from reflected traffic lights—pretty bland and also anything but uniform in both color and contrast. By fully illuminating the bridge elements with a flash and purple gel, I was able to call greater attention to the foreground element and get it to stand out in marked contrast to the distant skyline.*

Both photos: 16–35mm lens, ISO 200, f/11 for 3 seconds. Above: with Speedlight SB-900 with purple gel

You've already seen several examples in this book in which I turned the normally white light of the flash into light that was much warmer—light akin to the warm, golden glow of the low-angled sunlight found in early morning or late afternoon. In those situations, I was able to make the light much warmer with the use of an amber-colored gel placed directly in front of the flash head. Using gels with electronic flash is akin to using colored filters when shooting available light: You wish to add color to, or subtract color from, the light in the scene.

The amber gel I use is actually intended for indoor use where incandescent or tungsten light abounds. Typically, you would use this gel with your white balance set to Incandescent/Tungsten. With the gel attached to the front of your flash, the color temperature of the light being emitted by the flash becomes the same temperature as the Incandescent/Tungsten lights in the room. As you fire away, everyone and everything is bathed in the same color light: a somewhat-cool white.

Likewise, when you place the light-green gel that comes with the Nikon Speedlight SB-900 over the flash head and change your white balance to Fluorescent, you can expect to get nice, white-light pictures in an office setting, where fluorescent lighting is often found. The green gel converts the flash to the same color temperature as fluorescent lights, and when you then combine this color temperature with a Fluorescent white balance setting, you'll eliminate

the normal, sickly green cast that sometimes permeates the scene in office photographs.

Using colored gels, at least initially, is fun, and they do have their place. But as I've learned, gel use falls into that category of less is more. Yes, I often use the amber gel, but I seldom use any other, and believe me, it's not because there's a shortage of colored gels—heck, you can find gel packs that offer more than 250 colors! Can you imagine having 250 colored filters for your lenses? Neither can I, which raises the question, Why do you need 250 colored gels for your flash? You don't.

But assuming you want a few gels, the good news is they're easy to acquire. For example, my good friends at Adorama Camera sell the Rosco Color Effects Kit, which comes complete with fifteen different 10 x 12–inch colored gels, including the amber gel. The beauty of this kit is that you can then simply cut a custom size to fit your flash from the 10 x 12–inch gel sheet, and you still have plenty of extra left, which is a good thing, since I guarantee you'll lose that first one at some point in your flash photography journey.

The gels in this kit are so large because they're intended for studio photographers who use electronic flashes that are much larger and much more powerful than portable electronic flash units. The silver reflectors that often fit over these studio strobes require the bigger gel. But on the other end of the spectrum, if you're shooting with the built-in pop-up flash on your camera, you can easily wrap a sliver of a gel in front of that itsy-bitsy, teeny-weeny flash and attach it with a small rubber band. Just make sure the rubber band is wrapped around the gel and below the flash head itself so that the rubber band doesn't cover any part of the flash head.

Those who just want one gel can buy a single gel sheet in any color. The amber gel, in particular, is popular because it does a great job of warming up any given subject. Better yet, with that one gel you can keep your relatives away during the holidays! Seriously. Tell them that you're taking the family to Hawaii for the holidays, when in fact you'll be staying at home. Then sometime during that enjoyable, quiet holiday week, gather up your family and shoot a few waist-high portraits with your flash and an amber gel (make sure everyone wears T-shirts or beach attire). If you really want to make the shots extra believable, have the kids wet their hair in the shower and rub some soap in their eyes. The wet hair and red eyes, combined with the amber gel–induced tan, will make them look like they've been in a chlorinated pool all day! A few days later, after you get back from "Hawaii," e-mail your relatives a few of these shots. I am absolutely certain that they will comment on how tan everyone is!

There are also a variety of other light modifiers that can help you shape and filter the light from your flash. Diffusers are popular and useful tools for softening the light of your flash. These simple panels go in front of the flash head to spread out the flash light so that it's more dispersed and less concentrated. The effect is a less harsh light on your subject. Like gels, diffusers cause a loss of flash output, usually about 1 stop in my setups.

Unlike a diffuser, which both softens and spreads the light, a snoot considerably *narrows* the spread of the light. If you don't want to spill any gasoline on your sidewalk as you fill up the lawnmower with gas, you probably use a funnel. A snoot works in much the same way in that it funnels the light down toward the narrow opening at the end of the snoot. Your flash head attaches to the snoot, and when the flash and snoot are placed close to a given subject, a narrow circular spot of light is seen on the subject you're lighting.

WHEN WE PULLED INTO THE PARKING LOT next to a beach outside Tampa Bay, I commented to one of my students that we should return after dark and shoot one of the many parking meters with our flash. Based on his expression, it was clear that he was not looking forward to that outing. What's so interesting about a rusty old parking meter at night? he asked.

It was a fair question, but one I didn't answer, choosing instead to simply say, Trust me, you'll be glad you did when the night is over. Returning at night, I took one flash and attached a snoot. This became the foreground flash, which I aimed at the parking meter. I was able to zoom in the flash, narrowing the angle of the flash beam considerably so that only a portion of the parking meter was fully illuminated. In the background, my assistant reached over our "expired" model with his outstretched arm holding another flash unit. Based on the flash-to-subject distance, this flash required an aperture of f/8 for a proper exposure. I then powered down the foreground flash so that its required aperture was the same as the background flash (f/8).

Simple enough, and now all that remained was to mount my camera and lens on a tripod and set the lens to f/8. Since there was no ambient light to speak of, the shutter speed was irrelevant (because, remember, shutter speed controls ambient-light exposure). However, since I wanted an exacting composition, leaving no margin for any minor shift in point of view that sometimes happens when handholding the camera, I chose to use the tripod.

Nikon D300, 35-70mm lens at 35mm, ISO 200, f/8 for 1/125 sec., Speedlight SB-900

TURNING DAY INTO NIGHT IS NOW POSSIBLE—and easy—thanks to the powerful combination of flash and ambient light. With this setup, it was my intention to create a composition that suggested fear. What could be more fearful than knowing it's late at night and you're being followed as you leave the local bar? In an effort to run, you stumble across the sidewalk and your purse goes flying. How did I create a picture like this in broad daylight? With flash, a blue gel, and the deliberate and severe underexposure of the ambient light, that's how!

I set up this scene against an east-facing wall at around 3:00 PM, so the sun was directly behind the building and fully blocked from view. With my main model in place—kneeling on the sidewalk and with items from her purse scattered about (right)—the shot required two flashes, both used wirelessly attached to PocketWizards. One flash was held over the model's head and gelled with a blue gel, to replicate a blue neon sign that a club or bar might have outside its entrance. The second was ungelled and held behind a male model (on the far right of the setup shot below) as he assumed the pose of an attacker.

Since the flashes were at different distances from their respective subjects, I needed to power down the flash near the woman so that its output would equal that of the more distant strobe behind the man. Based on their respective flash-to-subject distances, both of my flashes were set to create a correct exposure at an aperture of f/16. At f/16, the correct ambient-light exposure was 1/15 sec. However, it was my intention to turn day into night, so with my shutter speed set to 1/250 sec., my ambient light would record as a 4-stop underexposure. This is pretty darn dark, and as you can see opposite, the resulting image did, in fact, transform day into night.

Opposite: Nikon D300S, 12–24mm lens at 20mm, ISO 200, f/16 for 1/250 sec., two Speedlight SB-900s

FOLLOWING A VERY EARLY START AND SEVERAL HOURS *of shooting lavender fields in Provence, my students and I took a coffee break in the small town of Puimoisson. Everyone was thrilled to finally get their morning cup of joe, including one of my students, Dennis. As I was sitting at the other end of the bar with several other students, I was quick to notice the extreme contrast in the rather dark café and the much brighter street behind Dennis. I then explained to several of my students just how easy it is to combine the available light exposure of the outside street with portable "sunlight" that we could create.*

Since I wanted some detail of the street outside and beyond Dennis, I used f/16. I decided that the flash would essentially frontlight Dennis and also chose to fire the flash through a small diffuser that would spread, as well as soften, the flash's light (above). Then I set my flash to f/16 and noted the corresponding flash-to-subject distance of 9 feet for a correct exposure. But experience has taught me that when shooting my flash through a diffuser I lose about 1 stop. To compensate, I cut the flash-to-subject distance almost in half. As you can see in the setup photo, the flash is about 5 feet from Dennis.

With my lens aperture set to f/16, I took a meter reading of the available light out on the street by simply pointing my camera and lens at the large, bright window at the end of the bar. The meter indicated 1/160 sec. for a correct exposure at my chosen aperture. At 1/160 sec. without the flash, Dennis would have recorded as a silhouette, but when I added flash, with my lens set to f/16 and my shutter speed still at 1/160 sec., I was able to render a pleasing portrait of him enjoying his cup of joe.

70–300mm lens, f/16 for 1/160 sec., Speedlight SB-900

WHEN WE REACHED THIS MOSQUE, *one of my students thought it would be a good idea to compose the scene with flowers in the foreground and using a wide-angle lens for a composition of great depth and perspective. All he had to do, he said, was wait for the sun to come up a little higher behind him so that the flowers and mosque would both be lit by the early-morning light. I loved the idea of incorporating the foreground flowers into the composition. But I was quick to tell him that if he waited for the sun to light the flowers, he'd be fighting his own shadow in that part of the composition. I suggested that he'd actually be much better off using his flash at that moment—before the sun got any higher on the horizon.*

The image above shows the scene as it was at that moment: recorded without flash, the foreground flowers not yet lit by the early-morning sun. But with our miniature sun, the flash, we could make my student's vision happen. Since we needed great depth of field, f/22 was appropriate. Set at f/22, the flash indicated a flash-to-subject distance of 5.4 feet for a correct exposure. But that assumed we'd be shooting the flash "naked," without any gels or diffusers in front of it. In fact, we were planning to use a small diffuser on the flash to soften the light. With a diffuser, the flash's power is reduced by about 1 full stop, so we needed to place the flash closer to the subject (about half as close as what the distance indicator told us). In the situation, that meant holding the flash about 3 feet from the flowers.

Looking through the camera, I could see that, at f/22, the light meter indicated a correct exposure of 1/60 sec. for the early-morning light reflecting off the mosque. So as long as we kept the flash at a distance of about 3 feet from the flowers, the flash exposure and the natural-light exposure of the rest of the scene would both be correct—and the same exposure in terms of quantitative value. So holding the flash overhead, about 3 feet from the flowers and pointed downward at a 45-degree angle, we fired away. The miniature sun did a nice job of illuminating the flowers without any worries of our shadows falling into the scene. Sure enough, about two minutes later the real sun rose behind us, just high enough to light up the flowers, and try as we might, we could not get the shot without casting our shadows all over the flowers.

Both photos: Nikon D300, 12–24mm lens at 12mm, ISO 200, f/22 for 1/60 sec. Right: with Speedlight SB-900

I ASKED MY MODEL, TYLER, to stand against a south-facing wall in Tampa. My assistant, Dave, then helped me transform Tyler into a dark, mysterious character, with only the aid of a flash and a single snoot. Standing back from Tyler at a distance of about 20 feet and handholding my camera and 70–300mm lens, I zoomed in to 300mm, filling my frame up nicely with Tyler's face. As you can see at left, Dave is right up on Tyler, holding the flash and a snoot covered with an amber gel about 8 inches away from his face. Due to this very close flash-to-subject distance, I powered down the flash considerably. When I reached 1/64 power, the flash's distance indicator said I could shoot at my chosen aperture of f/11 from 1 foot away. But Dave was closer even than that. Still, since I was using an amber gel, which absorbs about a stop of light output, I stayed at 1/64 power.

All that remained was to set an exposure for the available light. With my lens set to f/11, I merely adjusted my shutter speed until 1/60 sec. indicated a 1-stop underexposure for Tyler's face. Why a 1-stop underexposure? Because I wanted the light from the snoot to be center stage, and underexposing his face by 1 stop would do just that.

Opposite: 70–300mm lens at 300mm, f/11 for 1/60 sec., Speedlight SB-900

PETER KASTNER, THE BASS "MEISTER" FROM AUSTRIA (*right*), got his first taste of rock stardom at age sixteen. Austria quickly proved to be too small for this talented musician, and it was soon "America or Bust." Peter is truly a guy in love with music and, of course, his bass guitar. After stumbling into an alleyway just off Venice Beach, I remarked that the red wall and gargoyle figure would make a perfect backdrop for a portrait of Peter. While he went to get his guitar from his nearby car, I asked Randy Ray Mitchell (guitarist for Donna Summer, among others) to stand in for him so that I could set up the lighting and make some test shots (*above*).

As you can see, I used two lights. The rear strobe is off camera left and pointed at the wall and the gargoyle. The front light is off camera right and pointed somewhat straight at the subject. I placed diffusers over both strobes and also used light amber gels. Since I wanted the wall and gargoyle to remain somewhat "soft" while Peter was in sharp focus, I chose an aperture of f/5.6. I then dialed f/5.6 into the near flash and found that, at my 4-foot flash-to-subject distance, I'd need to power down the flash to 1/32 power. For the 5-foot flash-to-subject distance of the rear strobe, I found that 1/16 power was called for. So, with my aperture at f/5.6, I took a meter reading of the overall ambient light and got a correct shutter speed of 1/15 sec. Since I wanted to create a bit of mood in the scene, I underexposed my ambient exposure by about 1 1/3 stops (f/5.6 for 1/40 sec.). As you can see, the parts of the wall that are not lit by the flash give a somewhat moody feel to the overall exposure. And yes, Peter is indeed licking his guitar. Like I said, this guy loves his bass!

f/5.6 for 1/40 sec., two Speedlight SB-900s

Capturing Onstage Energy

One of the most common uses of flash is to capture onstage performances, which frequently have energy-filled, low-light subjects. This might have been a challenge before, but now that you're armed and dangerous with the knowledge of electronic flash, you'll feel like you can do almost anything. (You may even start running ads on Craigslist: Rock Band Photographer for Hire.) Whether you're shooting an indoor performance or wish to take the band outside, there isn't a lighting situation you can't handle. And just think of the many creative doors that are now yours to open! There has never been a great scientific breakthrough without preliminary experimenting, and the same is true with electronic flash technique—so get out there and take some chances! Every experiment that doesn't work moves you a step closer to the ones that do.

Note that in situations like the ones shown on these few pages, I sometimes work with one flash, sometimes two. Sometimes with gels, sometimes without. And almost always with my trusty PocketWizards, since I am a strong advocate of keeping the flash *off* the camera's hot shoe. And of course, 98 percent of the time, I'm shooting in Manual flash exposure mode.

COMBINING A LOW VIEWPOINT, *two flashes, and a bit of intentional camera movement enabled me to capture Butch Norton (drummer extraordinaire for the Eels and Tracey Chapman, among others) in a high-energy pose. Placing one flash behind Butch and another about 2 feet to my right caused Butch's shadow to fall toward me while also illuminating the front of him.*

Depth of field was not a huge issue here, so I went with f/11. When I input f/11 into both strobes, I saw that I'd need a flash-to-subject distance of 13 feet. So both strobes were on small stands at 13 feet: one 13 feet behind, the other 13 feet in front (and 2 feet to my right). I took an ambient reading off the traffic lights and nearby storefronts and found that a 2-second exposure at f/11 would be correct. Since the only light falling on Butch would be from my two flashes, I didn't set the shutter speed to a 1-stop underexposure; this allowed the ambient light around Butch to fully expose on the digital sensor. And finally, when I pressed the shutter release, I jiggled the camera a bit, knowing this would result in an artistic "painted" look. Since Butch wasn't lit by any ambient light, the exposure for him was 100 percent dependent on the flash. The flashes were set to rear-curtain sync, I jiggled the camera a bit, and just before the 1-second exposure was finished, the flashes fired, freezing Butch in the pose you see here.

Nikon D300S, 24–85mm lens, ISO 200, f/11 for 1 second

WHEN I MADE THIS SHOT,
I had been recently hired to photograph WaldoBliss (also seen on pages 108–109). After flying out to Los Angeles, I met the band members and within an hour was shooting their performance at a local coffee shop in San Pedro. Although not a critical performance for the band's photograph needs, it provided a great excuse to try some lighting tricks.

Here, singer, songwriter, and guitar player Dan Carlson belts out a tune. The low light level allowed me to try zooming my lens during the necessary slow shutter speed, and with my flash set for rear-curtain sync, the flash fired at the end of the zoomed ambient exposure. To set this up, I had my flash on a light stand about 10 feet from Dan, and for this flash-to-subject distance, the flash distance scale indicated f/11 as the correct aperture. At that point, I metered the ambient light in the room, and at f/11, the meter indicated 1 second as the correct exposure. However, since I would be combining flash and ambient light, I chose to shoot the ambient light at 1/2 sec., in effect underexposing the ambient light by 1 stop. I then handheld the camera, pressed the shutter release, and zoomed my lens from wide to telephoto, and at the end of this 1/2-sec. exposure, the flash fired—and a high-energy zoomed portrait of Dan is the result.

Nikon D300S, 24–85mm lens, ISO 200, f/11 for 1/2 sec., Speedlight SB-900

Creating Shadows for Added Drama

One doesn't have to be familiar with art to be familiar with shadows. Take an early morning walk on a sunshine-filled day and, with the sun at your back, you'll see your shadow, long and lengthy, falling before you. Shadows are commonly referred to in literary works, where they are often used as metaphors. Walt Whitman is noted for observing that you should keep your face always toward the sunshine so that the shadows will fall behind you. A common French proverb equates the shadow to a man's reputation: It sometimes follows and sometimes precedes him, it is sometimes longer and sometimes shorter than his physical stature. But it was Conrad Hall, a three-time Academy Award–winning cinematographer, who said it best: "Manipulating shadows and tonality is like writing music or a poem."

Shadows do change the melody of the photographic song, and other than the sun itself, nothing else but the electronic flash comes as close when it comes to creating shadows and readily changing the melody of your own photographic songs. I can recall numerous times when I found myself relying solely on Mother Nature to produce the desired light and looking up to the sky, my thoughts quickly turning grim as I faced the reality that there would be no sunlight coming my way anytime soon. Not anymore! My pockets are filled with portable sunlight!

Shadows impart that often-pivotal three-dimensionality; without shadows, we have neither texture nor form, and without form we have no volume. In the absence of textures, there is the absence of any substantial feelings. Study shadows in the natural world and soon you'll discover that low-angled light produces long shadows and sidelight emphasizes texture and form. Make a point of creating shadows with your flash simply by placing objects in front of your flash (see page 28 as an example).

Some objects throw a better shadow the closer they are to the flash, while others do a better job when placed farther from the flash. Since there are no film costs in the age of digital photography, trial and error is no longer a luxury but the norm! And because you have your own electronic flash, *you* are the sunshine, so get out there and start creating shadows that can precede or follow you no matter where your travels take you.

A BLUE WALL AND A WROUGHT- *iron window gate—what more can you ask for? Well, I asked Randy Ray Mitchell to stand against this blue wall in the corner where the window gate and wall met. Peter, seen on page 151, helped me with the flash; with his long arms, he was able to extend the flash beyond the gate just enough so that when I fired the flash I would record some wonderful shadows on the blue wall as well as some warm sidelight on both the subject and gate. The effect was that of an early-morning sunrise.*

To make the exposure, I had already determined that Peter would be holding the flash at about 8 to 9 feet from where my subject would be standing with his guitar, so I simply adjusted the dial on the back of my flash until I hit 9 feet and noted that the suggested aperture was f/11. With my camera now set to f/11, I took a meter reading of the ambient light and got 1/30 sec. for a correct exposure. But since I was combining ambient light with flash, I chose to underexpose the ambient light by 1 stop (1/60 sec.), as I felt the colors of the wall in particular would be a bit more vivid if underexposed. I fired a dozen or so pictures, and this is one of my favorites.

Nikon D300S, 24–85mm lens, ISO 200, f/11 for 1/60 sec.

"WHAT IF" IS A PHILOSOPHY
that travels with me 24-7, and it was on a small and very quiet street in Tucson that I put "what if" to work once more. Turning to my workshop students, I asked, What if we pretend this vacant house is being lit by low-angled sunlight instead of the overcast north-facing light we see here? With a single flash Nikon Speedlight SB-900, an amber gel, and the help of my VAL, Frank Carrol, the once ho-hum, flat, lifeless house is awakened by the light!

Over the course of the next thirty minutes, my students and I shot many variations of this blue wall and red door, making certain we were firing the flash into and through the many plants and bushes that grew in front of this house—to create the most interesting cast shadows.

Like so many other flash exposures, this one, too, was really quite simple. There weren't any depth concerns, so f/11 was the aperture choice. I dialed this into the aperture wheel on the back of my flash and found that at 1/1 power and with the flash head set to 28mm, the flash-to-subject distance needed to be 12 feet. But since the amber gel I was using would cause about a 1/2-stop of light loss, I knew I needed to come in closer to about 8 feet to maintain a correct flash exposure. As you can see in the setup shot, Frank is about 8 feet from the blue wall and doorway. He's also holding the flash, which means I was firing the flash remotely (in this case, using a PocketWizard on the camera's hot shoe that communicates with and fires the flash whenever I press the shutter release).

Nikon D300S, 12–24mm lens at 13mm, ISO 200, f/8 for 1/125 sec.

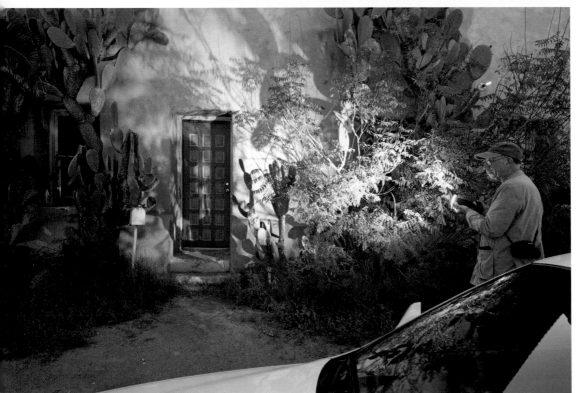

Index